HYDE
THROUGH TIME
Lee Brown

AMBERLEY PUBLISHING

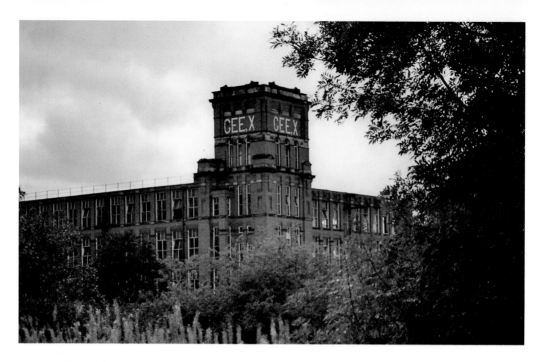

Gee X Mill, Apethorn Lane, After Closure in 1980
This is the mill Thomas Ashton had visited when he was murdered while walking home (*see page 40*).

I would like to dedicate this book to Bill Harrison, of Harrison's Newsagent's of Market Street, Hyde, and all the other independent shopkeepers and market traders who endeavour to keep trading against all the odds

First published 2013

Amberley Publishing
The Hill, Stroud, Gloucestershire, GL5 4EP
www.amberley-books.com

Copyright © Lee Brown, 2013

The right of Lee Brown to be identified as the
Author of this work has been asserted in accordance with
the Copyrights, Designs and Patents Act 1988.

ISBN 978 1 4456 1441 0 (print)
ISBN 978 1 4456 1457 1 (ebook)

British Library Cataloguing in Publication Data.
A catalogue record for this book is available from the
British Library.

Typesetting by Amberley Publishing.
Printed in Great Britain.

Introduction

Hyde is a small industrial town in north-east Cheshire, situated some 7 miles from Manchester. I have to confess, I wasn't born within the sound of 'Owd Jess', the great bell of Hyde Town Hall. I married a Hyde girl and I have played for Hyde Cricket Club for over forty years – so at least I can claim to be an honorary 'Hydonian'. In the thirty-odd years I lived in Hyde the town was vibrant: it had a busy market, a bustling main street with many independent shops and it was semi-rural, with many farms and open countryside close by.

Throughout the nineteenth and twentieth centuries Hyde relied on the production of cotton for its prosperity. By 1971, the cotton industry was already dying, mortally wounded by cheap imports from the east, but in Hyde there were three mills still working. My wife's sister and two brothers worked for Ashton Brothers, who had owned mills in Hyde since 1800.

The advent of the supermarket also played its part in the sad decline of the town. Many of the small shops struggled to compete and Market Street is now mainly cafés, fast-food takeaways and pawn shops. The building of the M67 (the motorway that goes nowhere) didn't help either as many houses, pubs, churches and shops were demolished in its wake. In the late 1960s the mills struggled to entice young people to train as spinners and weavers and so began an influx of immigrants from Asia, mainly Bangladesh, to take up the vacancies. Slowly but surely the character of the town changed and the sari, the burka and Friday prayers at the Mosque have all contributed to the multicultural diversity of Hyde. One only has to walk up Market Street and view the prevalence of curry houses and Asian fast-food takeaways, or the fact that we now have an Asian market day, to be in no doubt that Hyde's Asian community has had a considerable effect on the town. This, of course, is a purely personal view I hasten to add.

Another aspect highlighted in this book is the overgrown trees, bushes, grass and foliage. If the Victorians and Edwardians could keep the greenery trimmed with the limited equipment they had, why can't we? Many of the photographs I wanted to take were impossible because of trees spoiling the view.

The mass slum clearances from the Ardwick and Gorton areas of Manchester in the 1960s meant the lovely hamlet of Hattersley, which had some of the oldest farms and cottages in Hyde, was removed to make way for a vast new estate to house people who didn't want to live there. I often link this with the popular Pennine's song: 'Hattersley, Oh Hattersley, your spirit is wild and free. Your heart is made of concrete but you're Paradise to me.'

It was ironic, therefore, when the late Roy Oldham, leader of Tameside Council, revealed his master plan to transform the run-down estate. He envisaged creating five separate villages, each with their own identity and open spaces separating them. Wasn't that there in the first place? Some houses have in fact been demolished, but instead of creating separate villages they've constructed a giant Tesco store!

I have always been a keen photographer and usually have my camera with me. As Hyde began to change I endeavoured to record as much as I could on film. All the present-day

photographs were taken by me, with the exception of the steam train, which was taken by my good friend Gerry Robinson. In this book I aim to show how the heart of Hyde was torn out by planners of the fifties and sixties, and the awful designs and concrete monoliths the architects of that period came up with – the multi-storey car park in the town centre is just one example. I hope you enjoy the book.

Lee Brown

Acknowledgements

The majority of the old photographs in this book come from my personal postcard collection; however, I would like to thank the Tameside Leisure & Local Studies Library for allowing me to use many of the splendid photographs they have in their archives. I highly recommend a visit to their website – www.tameside.gov.uk/history/archives

Many thanks also to Paul Taylor for his excellent book, *The Pubs of Hyde*, which I have made much use of in compiling this book, as well as Thomas Middleton's *History of Hyde*.

I would also like to thank my dear wife Judi for her unflinching support with this project even when disturbing her at 4.30 a.m. while going out on another early morning photo shoot. I would also like to extend my thanks to Sarah and Joe at Amberley Publishing, for all their help and expertise.

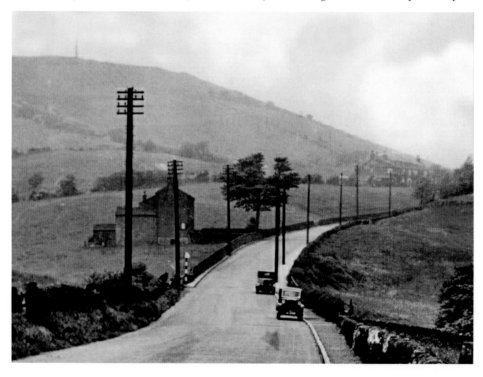

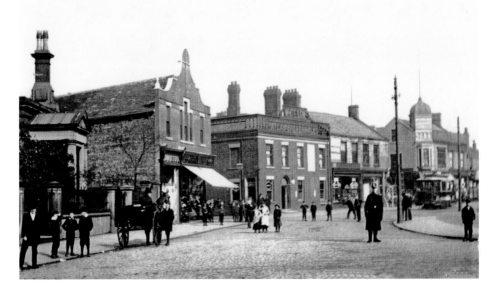

Above Market Place, c. 1910

A policeman keeps a wary eye on the photographer as he stands in front of the White Lion public house. A row of shops and then the Brownson Clothier store, with its prominent tower, are also pictured in the background. A single-deck tram has just left the Town Hall for Mottram. In the view below, from 2012, the White Lion is still there and if you fancy experiencing what a pub was like fifty years ago I recommend a visit. The Brownson Clothier store became Woolworths and, after their demise, it is now a Poundstretcher. The lovely building on the corner of Clarendon Street has been replaced by a soulless, windowless creation but at least it has a little style, which is more than can be said of the Boots chemist next door.

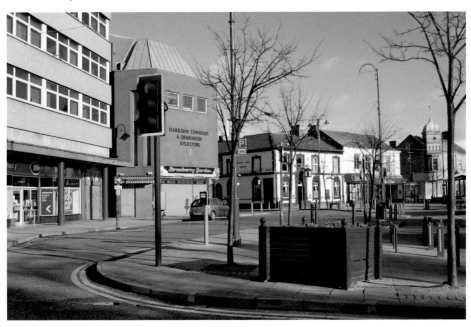

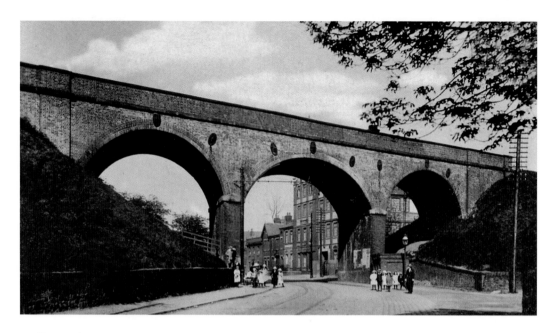

Godley Arches

A hundred years separates these two photographs of Godley Arches. The one above is from 1910 and Otto Monsted's margarine factory, later Maypole Dairy Ltd and then Wall's Meat Company, is visible through the centre arch and alongside it is the Olive Tree pub. In the picture below from February 2010, the factory, the pub and even the Victorian 'gents' behind the group of people on the right have all gone. The railway, which once saw expresses to Sheffield, Harwich and London, is now electrified but terminates at Hadfield with a short branch to Glossop.

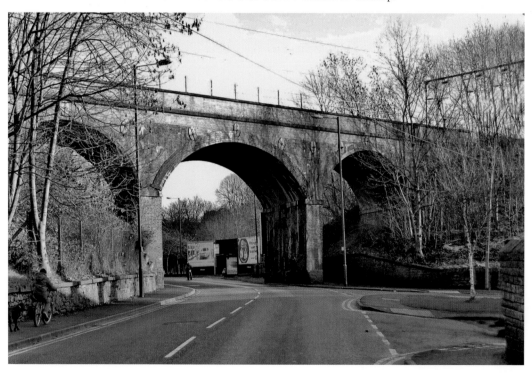

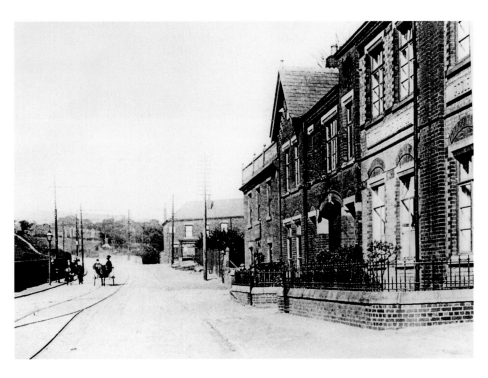

Otto Monsted's Margarine Factory, *c.* 1912

Above: On the far side of the factory is the Olive Tree public house. The earliest recorded evidence of a public house on this spot was in 1834 and the landlord was Joseph Lancashire. In the distance houses are visible at the bottom of Godley Hill, which leads up to Godley Fold and the Godley Hall public house. *Below*: The factory and the Olive Tree, which closed in 1922, have both disappeared in this view from 2012. When the factory outgrew the premises a vast new works was built just a few hundred yards behind the old one and is still in production today. It is owned by Kerry Foods.

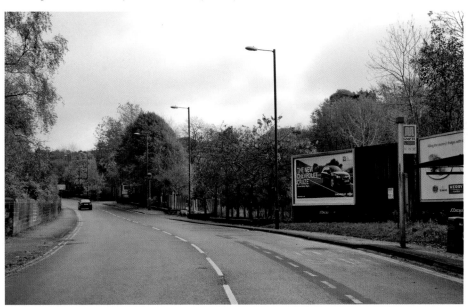

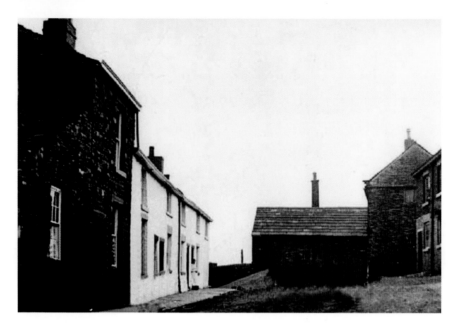

Godley Fold, c. 1905

Above: Of all the once numerous 'folds' in the area, Godley Fold is one of the last surviving. This photograph shows how easily the livestock could be enclosed when they needed to be. The Godley Hall Inn, as the name confirms, was once the manor house of the Godley or Godleigh family, the early owners of Godley. All traces of the original manor house have disappeared and the foundations of the present building probably date back to the mid-seventeenth century. There is an ornamental stone over the doorway with the inscription 'CIE 1718'. This refers to the Chadkirks, an old local family whose connections with Godley go back a long time. The earliest mention of a beerhouse on Godley Hill was in 1836 and the licensee was William Platt. The inn was once the headquarters for trail hunting, where a number of dogs would follow a scented trail laid by a runner around a devious course. The first dog back to the inn was the winner. The Godley Hill Royal Morris Dancers were also based here for many years. *Below*: In this view from 2012, the cottages on the right have been demolished and the inn and the remaining cottages renovated. I first called at the Godley Hall for a drink in the early seventies and the beer was still served by jug – to my knowledge it was the last pub in Hyde to serve beer this way.

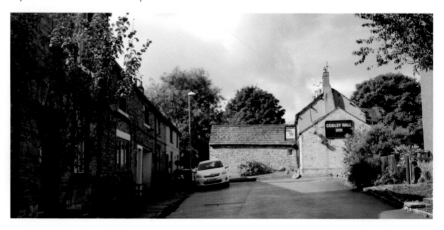

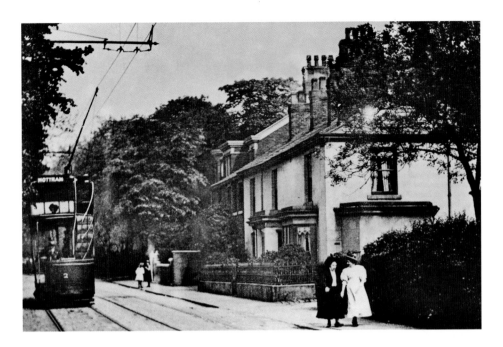

Mottram Road, Godley

Mottram Road, shown between the entrance to Oakland's and the location of the future St Paul's Hill Road. In the 1912 photograph (*above*) SHMD No. 2 tram heads for Mottram, and a mother and daughter enjoy a Sunday afternoon stroll. The daughter has cast off her dowdy Victorian clothes and embraced the new Edwardian fashion. Her mother, however, clings to her drab attire but bravely shows her ankles. In the view below, from 1988, the white house has been replaced by a new block of flats but the far house, which I think was once named Woodhouses, remains – although slightly altered in appearance. Building work is taking place in the grounds of Oakland's Hall.

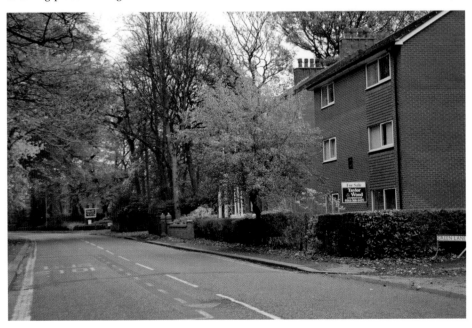

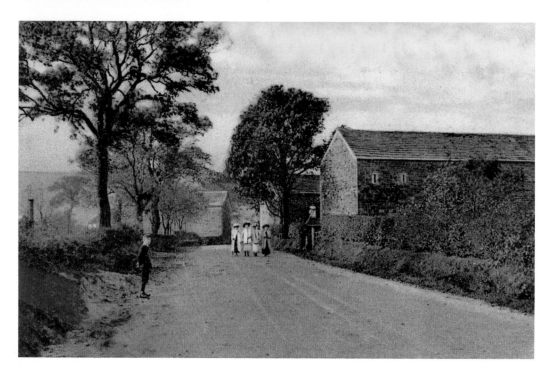

Mottram Old Road, Looking Towards Gee Cross, *c.* 1900

Above: Greenside Farm is visible on the right and, if you look closely, the chimney of a traction engine working in the field on the left can just be seen. The picture below is from July 2012 and while two of the farm buildings were demolished when the notorious S-bend was straightened a little, Greenside Farm still exists but now specialises in stabling. It also has a cattery.

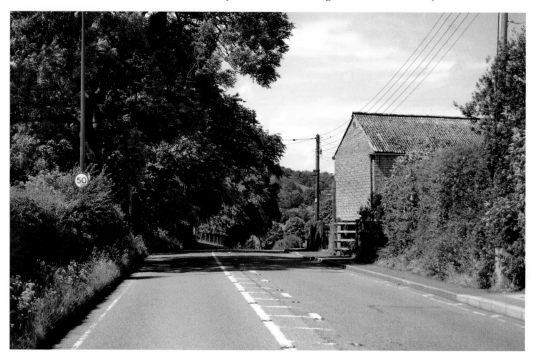

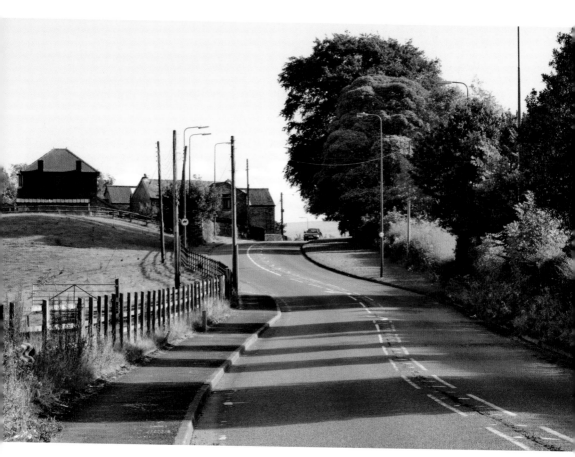

Mottram Old Road, Looking Towards Mottram, *c.* 1905

Right: I include this purely because there are not many postcards that have children with a donkey cart as a subject.

Above: The view from 2012 shows that all the buildings on the right were demolished when the road was straightened a little in the 1970s as it was an accident black spot.

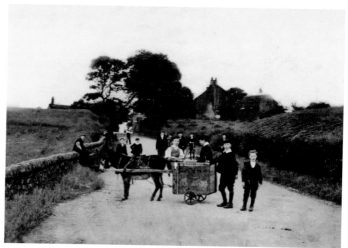

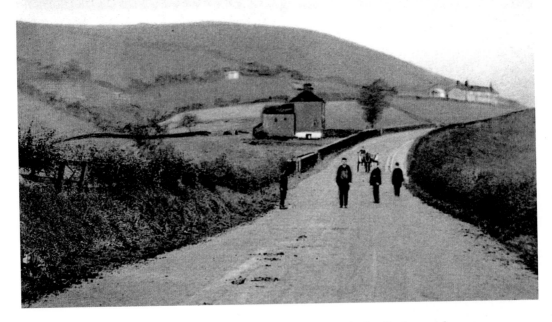

Mottram Old Road, With Werneth Low and Higham Cottages in the Background, 1909

Above: The road was built by 'Blind Jack' of Knaresborough, in around 1770. I say around because the exact date is unknown and several publications give varying dates between 1766 and 1777. The date of the photograph below is unknown but certainly after 1921 as the war memorial is in place on Werneth Low. Going by the cars, I would say around 1930. Apart from the telegraph poles, the addition of a footpath and a disappearing wall in the field, leading from the large house, little has changed. The poles on the right, presumably used for carrying electricity cables, have been placed in rather alarming positions right along the kerb edge.

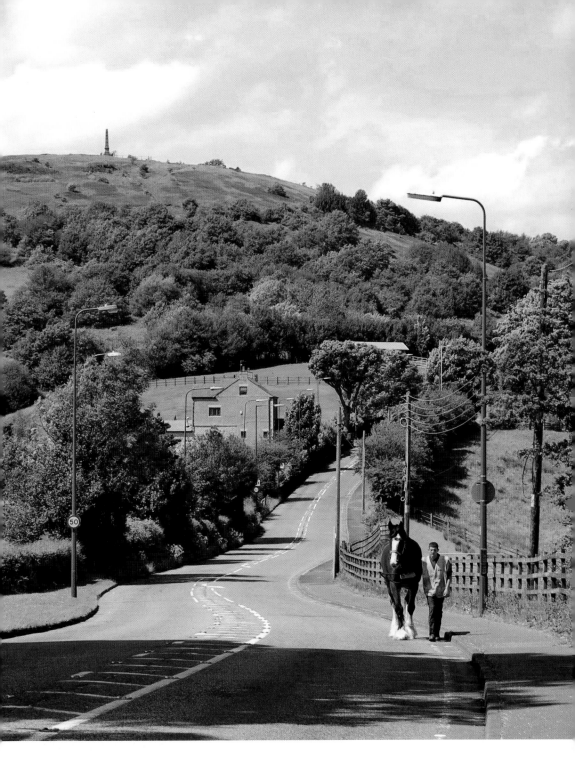

Greenside Stables
It is July 2012 and a stable boy is leading 'Big Boy' up to the stables at Greenside. Apart from a lot more trees, street lights and a new fence, not a lot has changed over the years. In my humble opinion this is one of the few views of Hyde that has improved with the passage of time.

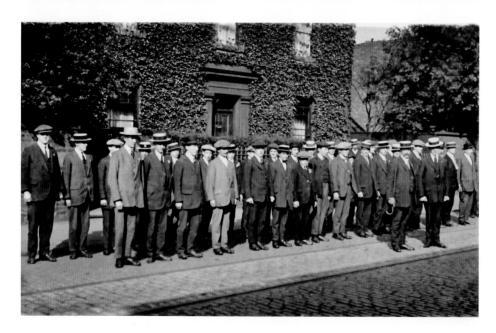

Mottram Old Road

Above: A postcard I purchased entitled 'Hyde, Cheshire 1914'. For a while it had me baffled – at first I thought the lines in front of the men were tram lines, but there was no such location in Hyde so I looked at the card again. After carefully scrutinising it I found the house on Mottram Old Road, with Werneth Low just visible behind. But what was going on? I can only conclude that these smartly dressed chaps were Hyde's 'Pals', ready to march into Hyde to volunteer. You wish you could shout at the picture and say, 'No. Don't do it. Go home. It won't be over by Christmas!' But the brave souls did and we know the rest. In the view below from 2012, the house is instantly recognisable, albeit with some cosmetic changes, but Werneth Low is unfortunately hidden by the trees.

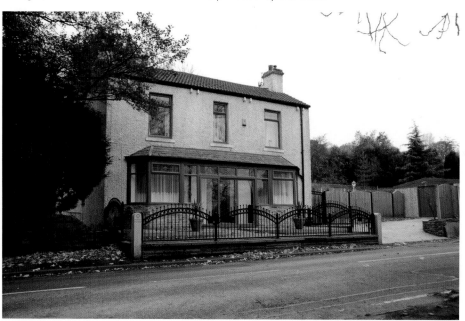

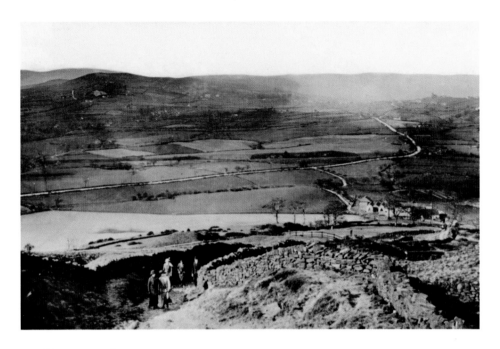

Ramblers on Apple Street, *c.* 1912

Above: A group of intrepid ramblers make their way up Apple Street from Mottram Old Road. The fields of Godley, Hattersley and Mottram spread out below, with Harrop Edge in the distance. *Below*: Rather than a photograph from 2012 I chose one I took in 1987, before the high-rise flats on the Hattersley estate were blown up. It is pleasing to note that the estate stopped at the railway and most of the fields this side of the line are still farmland. The picture was taken from a slightly different position as trees obscured the original view. The triangular field in the foreground links the two images.

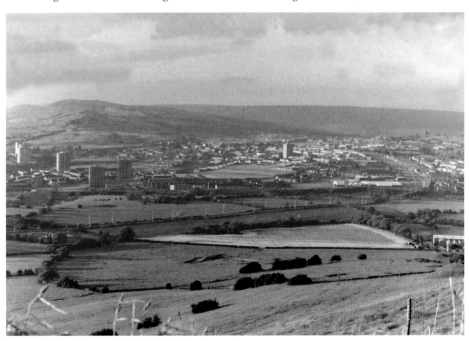

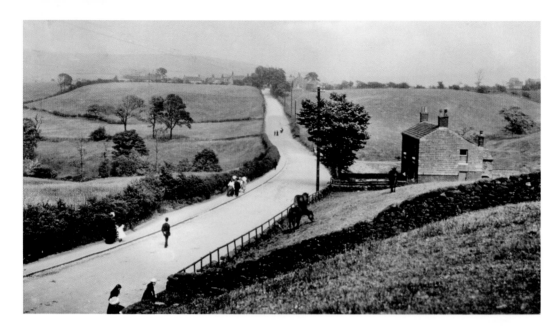

Mottram Old Road

Above: In this view of Mottram Old Road, we are looking from Higham Cottages towards where the cameraman was standing in the photographs on page 10. The year is 1912 and the telegraph poles are in place, but not the electricity poles on the opposite side of the road. Hydonians are enjoying an afternoon stroll while two ladies nearest the camera could be blackberry picking. In the view below, from July 2012, I had to move to a slightly different position due to the trees hiding Mottram Old Road. The large house from 1852 still stands and has recently been renovated. The trees hide the Hattersley estate over the brow of the hill.

ABC Lane, *c.* 1910

Above: A popular postcard of a house on ABC Lane, as it was known when this card was published around 1910. It is thought that ABC Lane came about because of the allotments that were present in those days, and each plot was given a letter rather than the usual number. In the view below, from July 2012, the name of the lane has changed to Green Lane, but the house is instantly recognisable and has been sympathetically looked after during the hundred years that separate these two pictures. I bet the road was in better condition all those years ago!

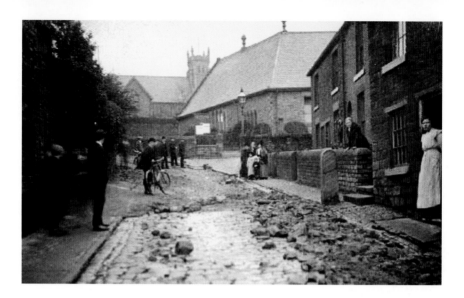

Higham Lane

Above: The residents of Higham Lane in Gee Cross survey the damage caused by the great flood of 8 May 1906. According to the account published in *The Reporter* at the time, the morning had been 'showery but the clouds cleared the sun appeared and a fine afternoon looked in prospect. Around four pm however, dark clouds massed and a strange calm descended which was broken by a clap of thunder that sounded like an artillery barrage and the heavens opened. Up to five inches of rain fell, before the storm moved away around five pm. Great devastation was reaped upon the town, especially in the Hoviley district.' Holy Trinity church and school are visible in the background. In the photograph below, from June 2012, the cottages on the right have been altered somewhat but the ones on the left and the church and school remain the same.

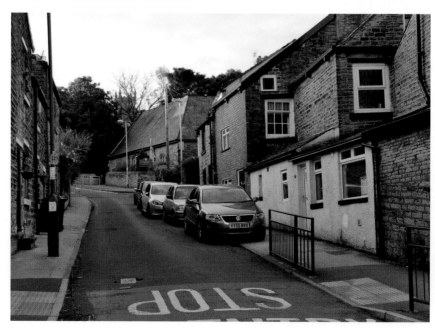

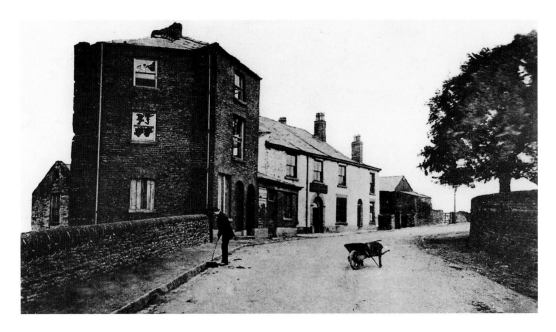

Eagle & Oak

Above: A lone street cleaner shovels up horse droppings outside the Eagle & Oak, No. 8 Mottram Old Road, Gee Cross, which could be pre-1900 as it looks as if it had already been closed for quite a while. The last landlord was John Godley, who left to take over the New Inn, just around the corner on Stockport Road, in 1884. The building was demolished not long after. In the view below, from 2012, only the wall gives any clues that we are in the same location. Just out of shot on the right are a row of cottages from 1858 called Mount Pleasant; it's a shame the photographer in 1900 didn't include them.

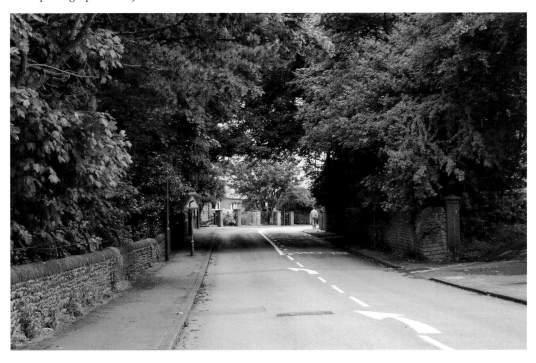

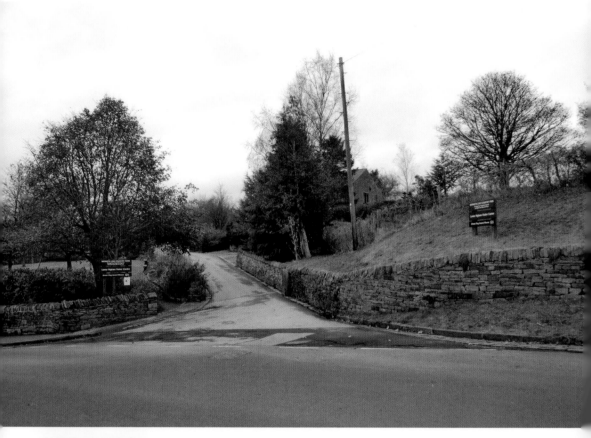

Lower Higham Farm

Left: An idyllic view of Lower Higham Farm, Gee Cross, with Lower Higham Lane in the foreground, around 1910.

Above: It was impossible to take the modern view from the same position, as a house now stands where the photographer stood in 1910. This is the nearest I could get. Higham Farm is still there but is now the Lower Higham Visitor Centre for Werneth Low Country Park. The right-hand gable end is just visible through the trees.

Aspland Maternity Hospital

Above: How many Hydonians saw their first light of day here? Aspland Maternity Hospital, on Lower Higham Lane, Gee Cross, is pictured here just before its demolition in 1987. The house was given to Hyde council in 1922 by the widow of and son of Mr Arthur Palmer Aspland, a leading figure in the industrial and social life of Hyde. The hospital had two wards, fourteen beds and was run by a matron, two midwives, a cook, a laundress and a caretaker. *Below*: This picture from June 2012 is as close to the original position as I could get, as a small upmarket estate was built in the grounds. *Inset*: This is the only surviving part of Asplands and can be seen on Lower Higham Lane.

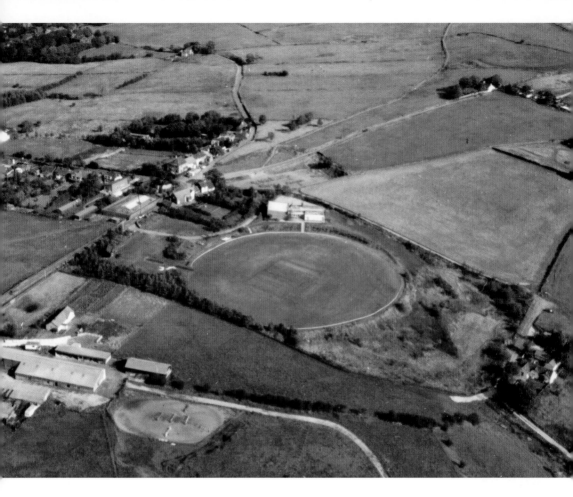

Werneth Low

An aerial view of Werneth Low taken by Airviews of Manchester Airport in 1975 and commissioned by Hyde Cricket Club, whose almost perfect circular ground forms the centrepiece of the photograph. Joel Lane can be seen coming up on the left of the picture and Higham Lane drifts away to the top left. Mount Road runs alongside the cricket ground and Werneth Low Road runs to the centre from the bottom left and carries on up to the top right past the golf club. Hillcrest and Mount Cottages are at the junction of Joel Lane and Higham Lane and at the top of Higham Lane, hidden by a mass of trees, Aspland's Maternity Hospital is situated. It was still a working hospital when the photograph was taken. The Hare & Hounds public house is just out of shot on the left.

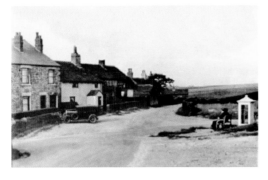
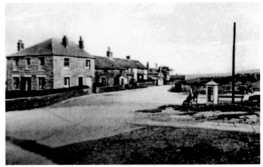

Werneth Low Road, c. 1925

These photographs show Werneth Low Road, Gee Cross, at the junction of Joel Lane, Higham Lane and Mount Road. The large house on the left, on the corner of Joel Lane, is Hillcrest and the third cottage along is a shop were you could get a cup of tea and a scone. The white structure on the right is an early telephone kiosk. In the current view below, from February 2012, Hillcrest and all the cottages survive albeit with added porches and foliage. The telephone kiosk has been replaced with one of Sir Giles Gilbert Scott's iconic K6 models. The lone Morris Cowley has been replaced by Audis, Volkswagens, Jaguars and a very ugly skip. Street lighting has also appeared, although I thought the local authority could have been a little more sympathetic with the choice of the lamps in a conservation area.

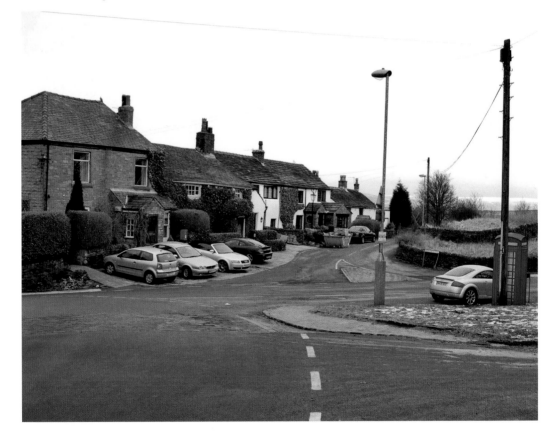

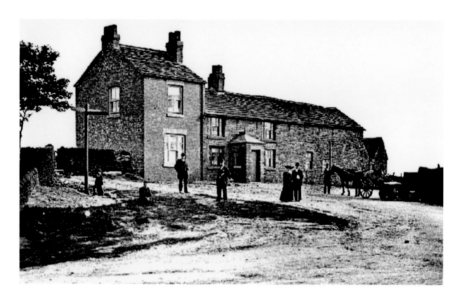

Mount Farm

Above: Mount Farm at the junction of Werneth Low Road, Joel Lane and Mount Road, pictured here at the turn of the century. Werneth Low would have been quite a busy place around this time with many farms, cottages and homesteads, as this image seems to prove. *Below*: In this photograph from September 2012 the farm has been converted into cottages and the row is called Mount Cottages. Note that the barn at the end of the row and the smaller detached barn have been converted into living accommodation. You can also see from this view that an additional cottage has been added to the gable end nearest the camera. Mount Road runs alongside the new cottage and Hyde Cricket Club's lovely ground is behind the row.

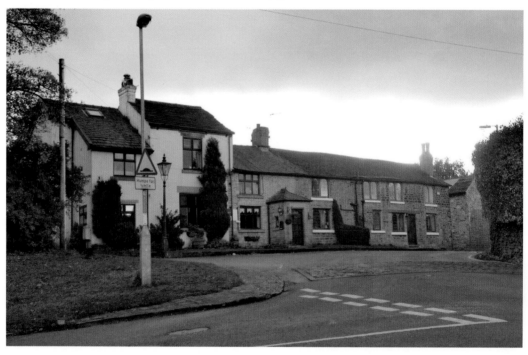

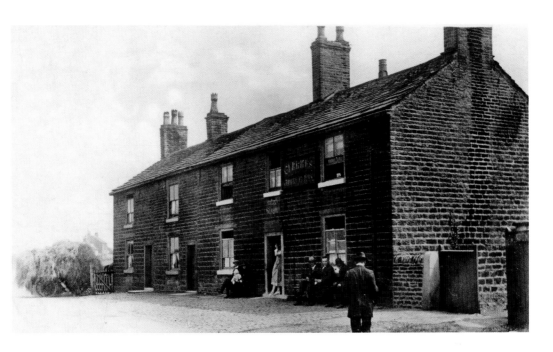

Hare & Hounds, Werneth Low Road, c. 1925

This is one of the oldest licensed public houses in the district and records show there was an inn here in 1754. In 1920 the building had no electricity, running water or sanitation. When the renowned landlord Walter Mansfield took over in 1934, he used to collect two quarter-barrels of beer a week from the brewery in his horse and cart and sell it at 5*d* a pint – more about Walter later. Mount Farm, from the previous page, can be seen in the background. In the photograph below, from July 2012, the pub is now a popular Chef & Brewer. On a nice day the place is packed with people enjoying good food and views that extend over Greater Manchester, Lancashire and Cheshire. On a clear day you can see as far as Merseyside and Snowdonia.

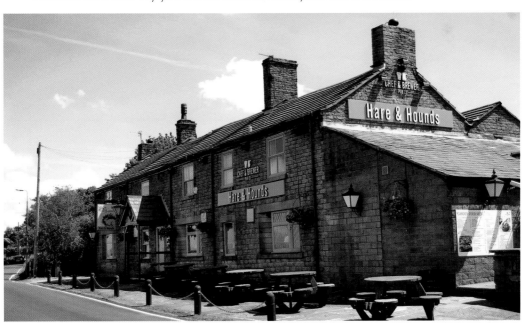

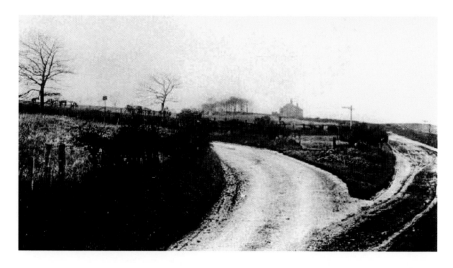

The 'Triangle'

Above: Pictured in 1920 with the Top o'th'Low house, as it is called today, visible in the background. This is Hyde's boundary with Stockport and where Werneth Low Road meets Cowlishaw. It was here in 1967 that Queen Elizabeth, who was on a tour of Cheshire, planted one of the trees seen in the picture below from June 2012. HRH was greeted by several local dignitaries, one of whom was the aforementioned Walter Mansfield, alias 'The Squire of Werneth Low' and landlord of the Hare & Hounds. Legend has it that Walter, who was an ex-miner, was so worried about the state of his hands that he wore gloves when he shook HRH's hand – he was the first person ever to shake her hand while wearing a glove. It is also said that he invited her back to his pub for half a Boddingtons and a packet of smokey bacon crisps! She politely declined. I have a lovely memory of Walter when I took my future wife in for a drink in 1969. Sitting down in a corner with our drinks she snuggled up to me and I had just put my arm around her when Walter's voice boomed out via a microphone: 'We'll 'ave none of that going on in 'ere. Be'ave yerselves!'

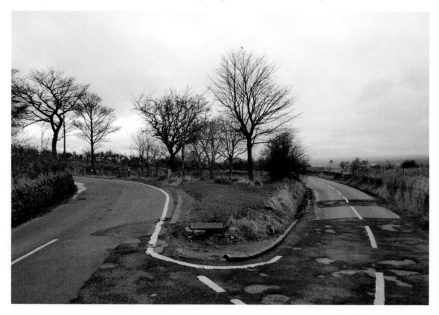

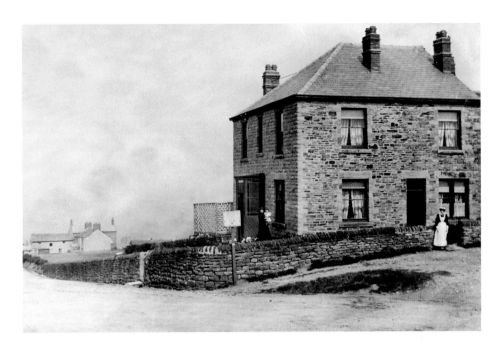

Hillcrest

Above: One of the grandest houses on Werneth Low in 1912 was Hillcrest, at the junction of Joel Lane, Higham Lane and Werneth Low Road. The maid and possibly the nanny pose for the camera, with Hillside Farm on Joel Lane visible in the background. *Below*: The inevitable trees and bushes hide much of Hillcrest today. It has altered little in a hundred years, though inside it is now divided into several dwellings.

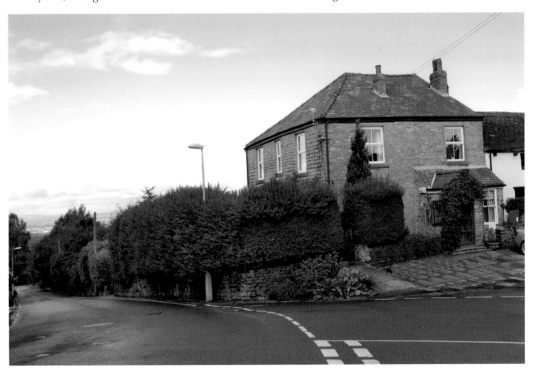

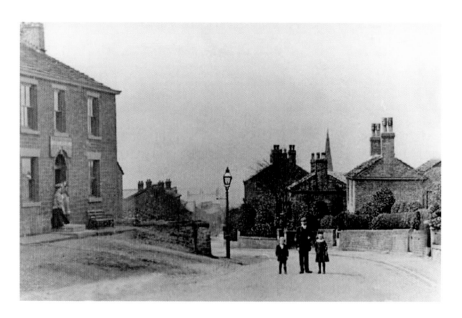

Joel Lane, *c.* 1912

Above: Joel Lane, Gee Cross at the junction where Arnold Road now stands, with the future Slateacre Road just beyond the lamp. The Travellers Call public house on the left was first licensed by Joseph Saxon in 1850. *Below*: The sale of liquor ceased in 1931 but the house still stands and in the garden is a small stone building once used to make moulds for bowler hats. All the houses on the right still stand and the spire of Hyde chapel can be seen peeping over the rooftops.

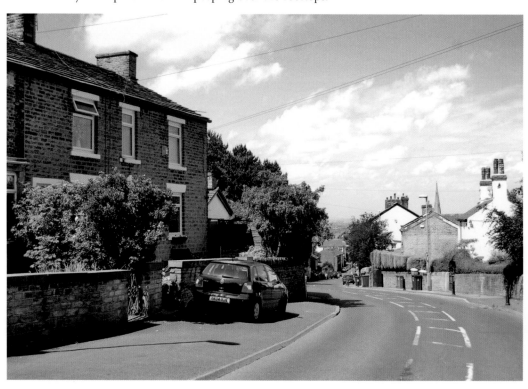

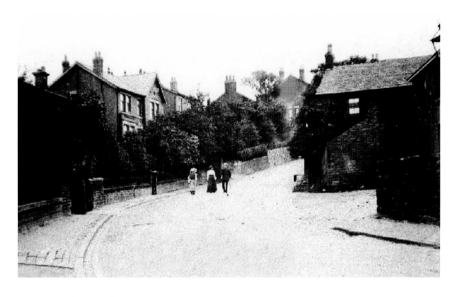

The Travellers Call, c. 1912

Above: In this view of the Travellers Call the photographer is situated on Arnold Hill, looking up Joel Lane. The three people in the photograph have just passed the spot where Arnold Avenue would be created. It is said that the Travellers Call lost its licence in 1931 because the hat workers used to call in for a drink after work and were always falling out and fighting over wages. A local councillor who lived opposite objected to the licence. His objection was upheld and the pub closed in 1931. *Below*: In the view from September 2012 not a lot has changed except the creation of Arnold Avenue on the left. The Travellers Call has been converted to a house, with a garden occupying the frontage.

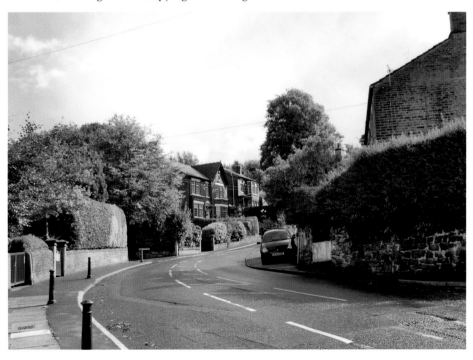

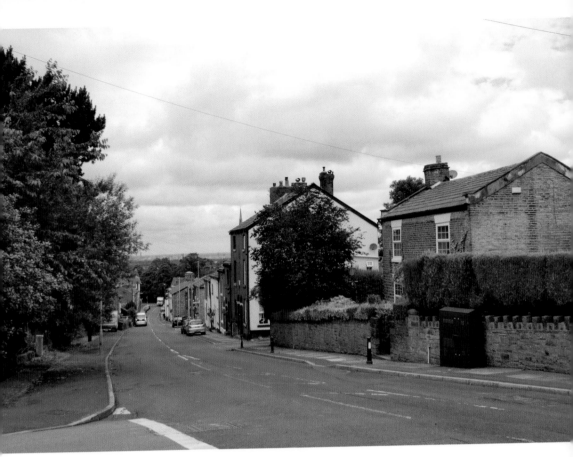

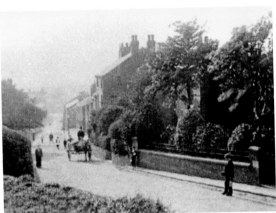

Joel Lane, From the Junction With Slateacre Road, *c.* 1905

Left: It is late afternoon, judging by the shadows, and a horse and cart makes its way up to Werneth Low. A man contemplates the cobbles and in the distance a giant stands in the middle of the road, while a young boy makes his way home from school. *Above*: The cobbles have been replaced and cars rule the road instead of horses, but otherwise remarkably little has changed. The house that is now visible on the right is called Loughrigg Cottage.

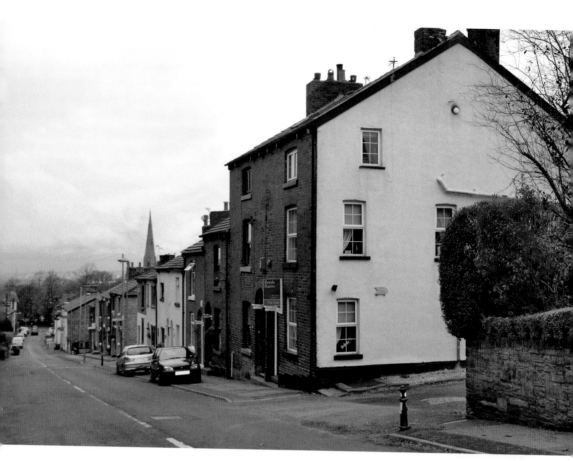

Joel Lane, *c.* 1955
Joel Lane again, pictured from a different angle. I have included this photograph to show how little has changed over the years, as seen in the view from 2012. The ever present spire of Hyde chapel is visible above the rooftops in both pictures.

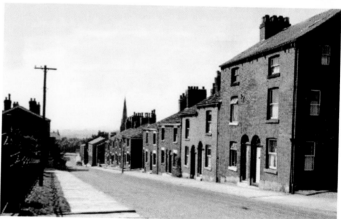

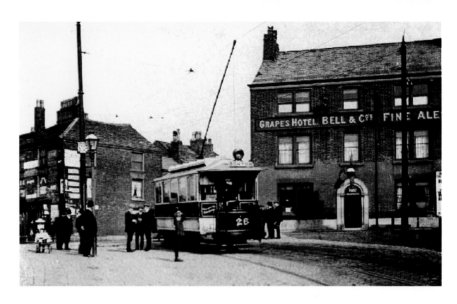

The Grapes Hotel

Above: The Grapes Hotel selling Bell & Co. Fine Ales was the premier house in the district. Records show that the Grapes Inn stood on the same spot in 1777 and there are still pieces of the original building left. The area in front of the hotel had always been popular as a meeting point, probably dating back to when Hyde Wakes Week was celebrated there. The Grapes was also famous for prizefighting contests and was the starting point for stagecoaches to Stockport in the early 1800s. A No. 26 single-deck tram passes on its way to Ashton around 1908 – note that the Grapes hasn't received its stripes yet. (*Below*) In the view from 2012, considerable alterations have been made to the façade of the hotel over the years, and to the house/shop at the bottom of Joel Lane. The Grapes is still a popular meeting place and has recently reverted back to hotel status, offering rooms, good food and a well attended quiz night.

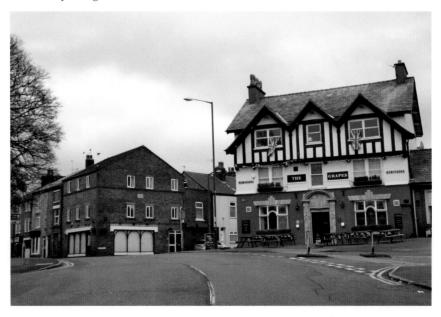

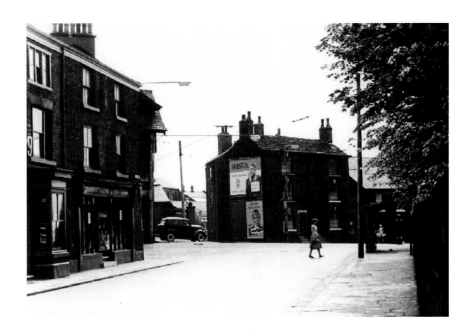

Stockport Road, *c.* 1954

Above: Trolleybus wires have replaced tram wires in this view of Stockport Road, at the junction of Joel Lane, Gee Cross. A Ford Popular is parked at the front of the Grapes public house. In the distance behind the car is Wych Fold. The larger of the two advertisements on the gable end facing the Grapes is for Bristol cigarettes at 3*s* 4*d* for twenty. The shop on the corner was a grocer's and the shop nearest the camera was a baker's. (*Below*) The house with the advertisement hoardings has disappeared, along with Wych Fold. They were demolished when the fields behind became the Lord Derby Road and Brabyns Road housing developments. The house with the prominent gable end in the background dates back to the seventeenth century. On the corner of Joel Lane the shops have gone and the building was totally rebuilt in 2002.

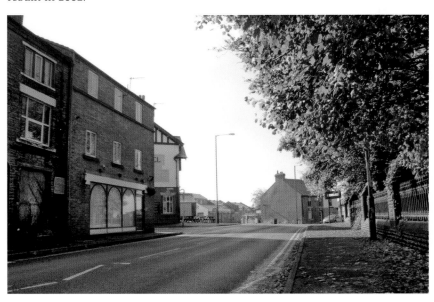

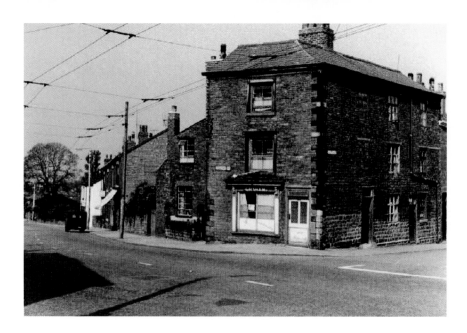

Stockport Road, *c.* 1955

Above: In this view we look across from where the Ford Popular was parked outside the Grapes to Johnny Graham's barber's, Stockport Road, junction of Knott Lane, Gee Cross. Dennis Graham, one of Johnny's sons, was a friend of mine and he said Johnny only ever did one type of haircut – no matter what you asked for you got a short back and sides. Needless to say Dennis went to Suskas! *Below*: The barber's shop is now a private house. The trolleybus wires disappeared in the mid-1960s, but not much else has changed in this view from 2012. The trees on the right are in the grounds of Hyde chapel.

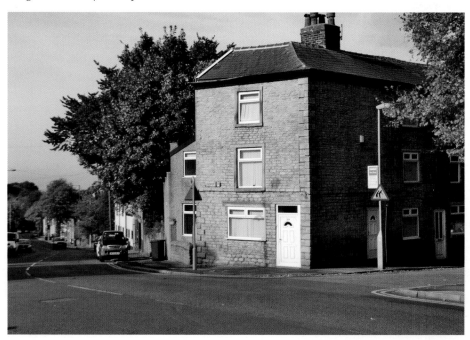

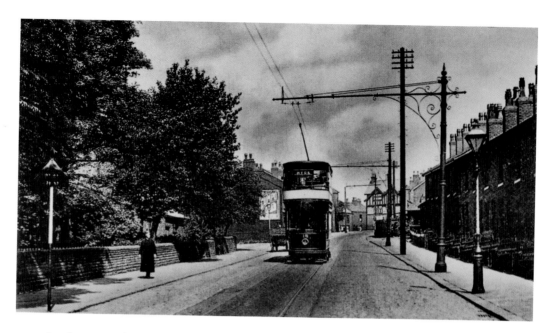

Stockport Road, *c.* 1912

Above: We have moved a little further down Stockport Road and are looking back up to the Grapes Hotel. The date is a few years prior to the previous picture of the Grapes, as we now have the mock Tudor stripes on the frontage and a SHMD double-deck tram heads for Hyde Town Hall. *Below*: In the view from 2012 the gas lamps and the trams have gone but everything else remains much the same.

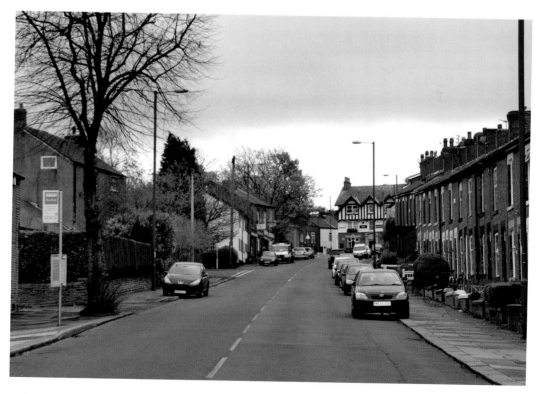

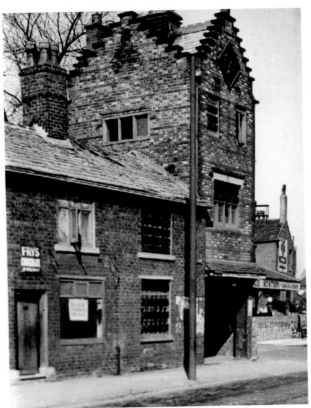

Gerrards

Left: This row, which the locals called Gerrards, stood on Stockport Road at the junction with Apethorn Lane. It included a shop and an unusual tower, complete with a clock provided by Ashton Brothers for the benefit of their workers at Gee X Mill. The advertisement on the wall is for Fry's chocolate and there was a garage on the opposite corner. *Below*: As can be seen in this 2012 view, everything was later demolished, including the parsonage for Hyde chapel that stood behind the buildings on Apethorn Lane, when the junction was widened and a new garage replaced them.

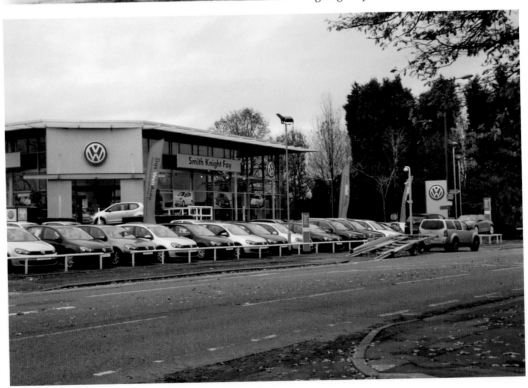

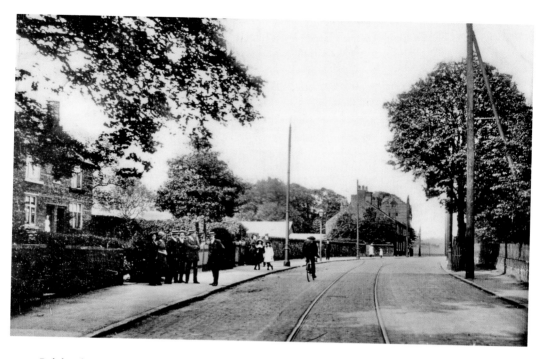

Polebank Cottages, Stockport Road, Gee Cross, *c.* 1912

The picture above is one of my favourite photographs of Hyde and seems to embrace the idea we have of those idyllic years just prior to the First World War, with endless sunny days, straw boaters, bicycles and little girls in their best Sunday dresses. As the picture below from 2012 proves, the seventeenth-century cottages on the left are still there – and I should know because I almost bought one! Bagshaw's Farm and Hyde Cricket Club's old ground are beyond the cottages, and in the distance, where the Smith Knight Fay garage now stands, the clock houses seen in the previous photograph are visible.

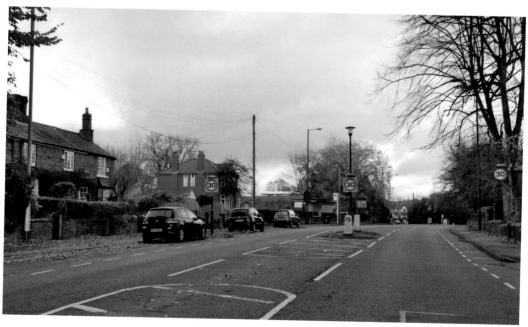

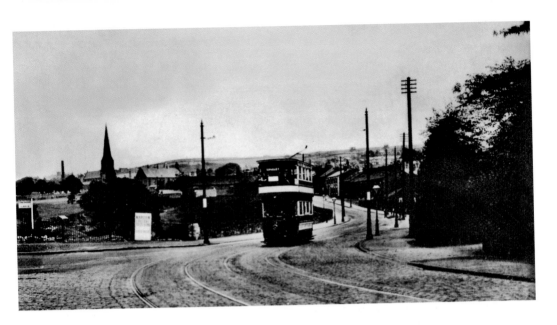

Gerrards, 1912

In the picture above SHMD tram No. 41, bound for Stockport Edgeley, comes round the bend at Gerrards, Pole Bank, on Stockport Road. This location is directly opposite the row of cottages seen on page 37. Werneth Low, Hyde chapel and Enfield Street School can all be seen in the background, while the Lamb Inn and the Cheshire Cheese public house are visible in the middle distance. The poster advertises a concert by the Marsden Colliery Band, presumably at the Town Hall. In the photograph below, from June 2012, a small park has been created and Dowson Road is now in place on the left where there were once just fields and trees. Foliage and shrubbery obscure everything else.

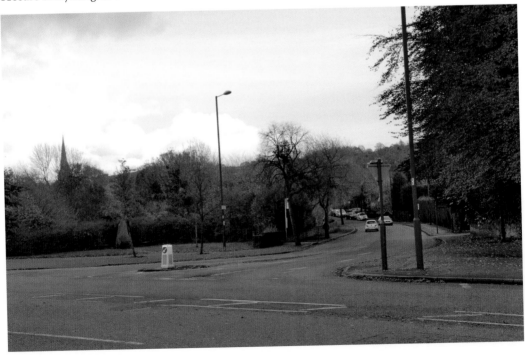

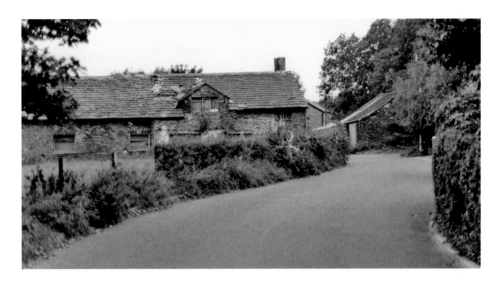

Apethorn

The photograph above of Apethorn Barn on Apethorn Lane, Gee Cross, looks as if it could have been taken a hundred years ago, but I actually took it in 1975 when I was looking for the location of Thomas Ashton's murder. Thomas was the youngest brother in the mill-owning Ashton family and, according to a contemporary account, 'He had just left Gee X Mill when he was confronted in this area by three men, one of whom ran forward and shot Mr Ashton through the heart at point blank range. The three then ran off leaving the victim lying in the middle of the road. Mr Ashton was carried to his father's house at Pole Bank but was a corpse before they reached it.' Two men were eventually hanged for the brutal murder, Joseph Moreley and William Garside. They were convicted on evidence provided by Moreley's brother William, who was confined in Chester Prison, hopeful perhaps of reaping the reward of £2,000 that was on offer. No motive was ever established for the attack but the general consensus of opinion at the time was that it had something to do with the unrest in the Ashton Brothers' mills because of low pay and redundancies. In the view below, from June 2012, the roof of the barn has been covered in plastic sheeting to try to preserve what is left of the ancient building. Trees and bushes hide everything else and the inevitable yellow lines have appeared.

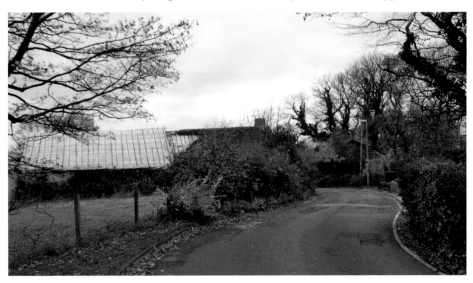

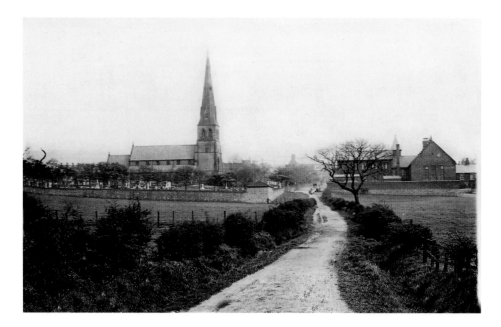

Knott Lane

Hyde chapel and Enfield Street School are the only clues that these two photographs were taken from roughly the same place on Knott Lane, Gee Cross. The picture above, from 1915, shows how rural Hyde, and especially Gee Cross, once was. Knott Lane in those days meandered its way from Stockport Road, past a group of cottages called Woodfold just out of shot on the left. It then crossed the fields where Dowson Road is now situated, eventually crossing the railway via a footbridge to the hamlets of Knottfold and Foxholes. The photograph below was taken at the junction of Marlborough Road and Sandringham Road in February 2009.

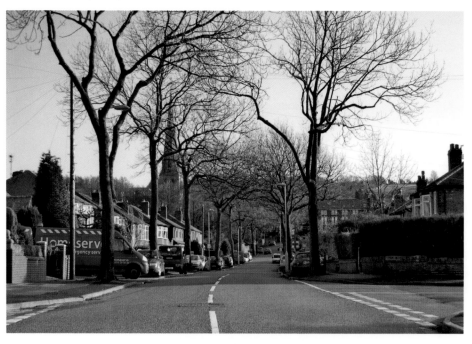

Dowson Road, *c.* 1935

Above we see a pristine and practically traffic-free Dowson Road, which only opened a few years before this photograph was taken. The road was named after one of the town's most notable figures, the Revd Henry Enfield Dowson BA. He was Minister at Hyde chapel from 1867 to 1917 and Enfield Street School was also named after him. In the view below, from June 2012, nothing much has changed apart from the road markings, the number of cars and the price of the houses of course!

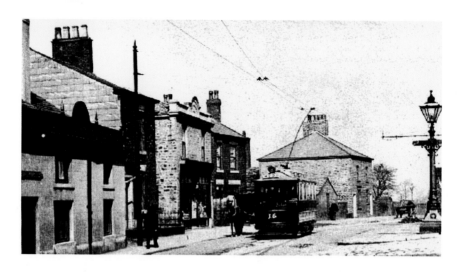

Junction of Stockport Road and Mottram Old Road, Gee Cross, c. 1905
SHMD single-deck tram No. 16 heads back to Hyde Town Hall from Gerrards, passing a horse and cart outside the shop with the Red Lion public house on the left. In the view below, from July 2012, the magnificent lamp has gone but its base remains in use as a direction sign. The Red Lion pub has disappeared, as has the house next door and the shop is now a Tesco store. All the other houses remain much as they were in 1905.

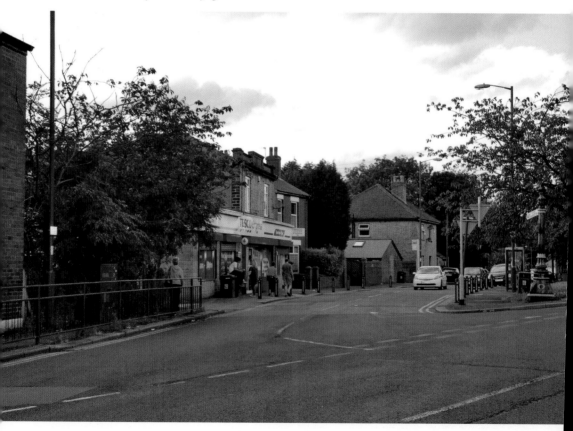

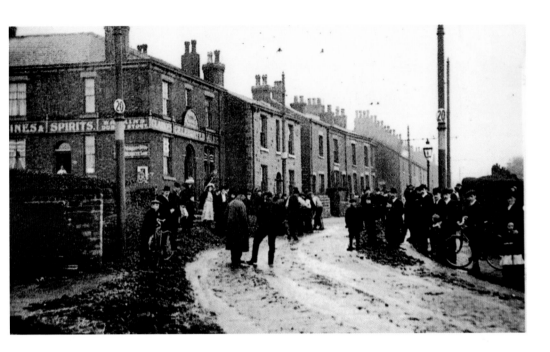

Werneth Hotel

Above: A rather grainy picture of the Werneth Hotel on Stockport Road, Gee Cross, which shows the aftermath of the great flood in May 1906. According to a contemporary account, 'Torrents of water came down off Werneth Low and Treacle Brow and Stockport Road were like rivers'. The Werneth began life in 1838 as the William IV, but over the years has had a variety of names, including the King William IV and the Hatter's Arms, before becoming the Werneth. In 1960 the landlord was Cephus Howard, who was instrumental in forming the popular band The Temperence Seven. They had several hits, the most famous being 'Pasadena'. *Below*: A somewhat more peaceful view on 4 July 2012 and apart from the trees and the vehicles little has changed.

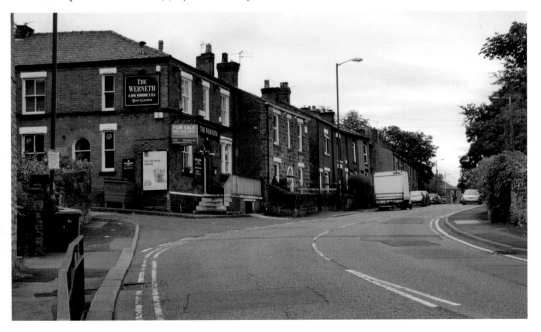

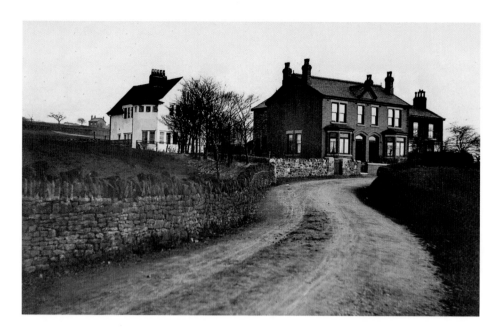

Backbower Lane

The photograph above was the hardest location to identify. The date on the house, pictured in Backbower Lane, is 1902, so the photograph must have been taken around 1905. Apart from the large double-bay house and the unusual white house at the rear, everything has since completely changed. The photograph was taken from the Grange Road end of Backbower and the rural aspect of Gee Cross is readily apparent. In the view below, which I took in July 2012, it was impossible to stand in the same position because of modern development. I have included a photograph of the house to ensure it is recognisable to readers.

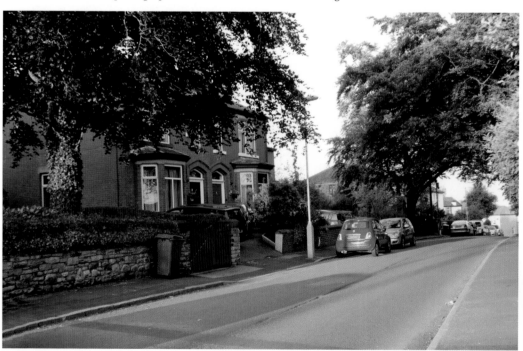

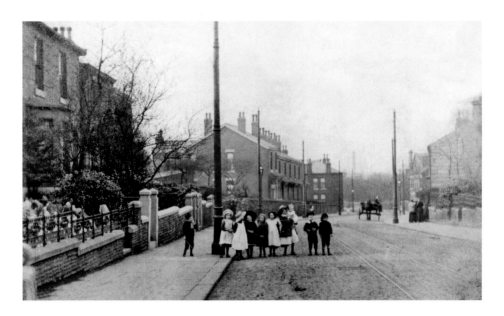

Stockport Road, c. 1912

Above: Stockport Road, near to Lilley Street, looks down towards the Clarkes Arms. On consulting the 1871 map of Hyde there were very few houses on this part of Stockport Road. Silverhill House is (I think) the large building behind the terraces on the left and that, apart from a couple of houses on the right, on the corner of what is now Rowan Street, is all there was. The rest of the picture would have been fields. The chimney of Slack Mills can be seen in the distance. What a difference thirty years made, but compared to the photograph below, there has been very little change. Slack Mills has gone and a few of the houses on the left have been replaced by modern flats, but on the right all remains the same. The gabled end on the right, the house on the bend in the distance and the wall on the left link the two pictures.

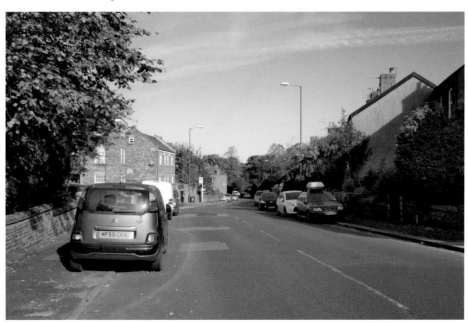

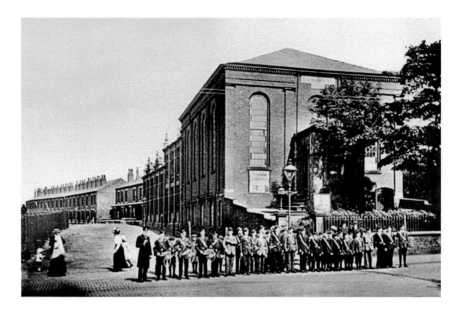

Zion Chapel and Sunday School, *c.* 1900

Above: I would guess that it is the first Sunday morning of the month and the Boys' Brigade are assembling for church parade on the corner of Peel Street and Stockport Road. Again referring to the 1871 map, Peel Street did not exist and Zion chapel stood in the corner of fields that stretched all the way back to Mottram. In the view below from 2012, the massive old chapel has been demolished and replaced by a smaller modern building. It is pleasing to see that the houses further back on Peel Street all remain, complete with their porches. I have a chilling memory of Zion chapel from when I used to play table tennis. The room they used was at the top of a long flight of creaking stairs and when I reached the top I listened for the sound of ball on bat, but there was only silence. I walked down the dingy corridor and hopelessly got lost, until eventually the caretaker told me where to go. When I informed the Zion team of my encounter they replied, 'What caretaker? We haven't got one!' I wonder if he moved to the new building as well.

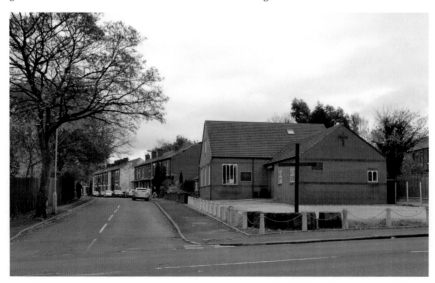

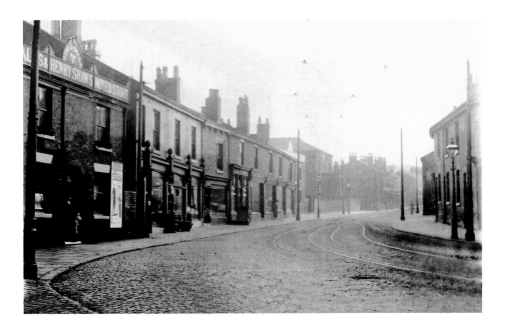

Ring O'Bells Public House

Above: Taken from a 1912 postcard that had seen better days, we see Stockport Road, with the Ring O'Bells public house on the left, the Clarkes Arms further up and Zion chapel just beyond on the corner of Peel Street. *Below*: Remarkably every building, apart from the Zion chapel, is still in place in this view from July 2012. The Ring O'Bells opened for business in 1850 when it was two cottages with a smithy at the end. One of the cottages became a beerhouse, which later extended into the second cottage. The smithy at the end, which is just out of shot, remained until 1950, when Hyde Corporation and Slack Mills used to have their horses shod there. The pub has since closed and is now boarded up.

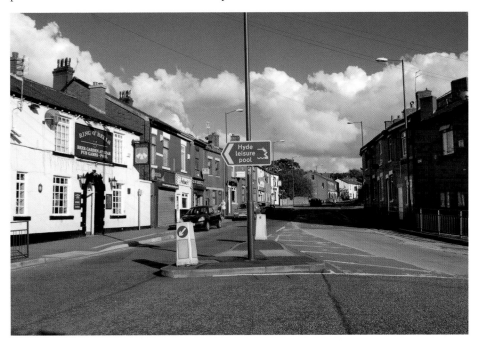

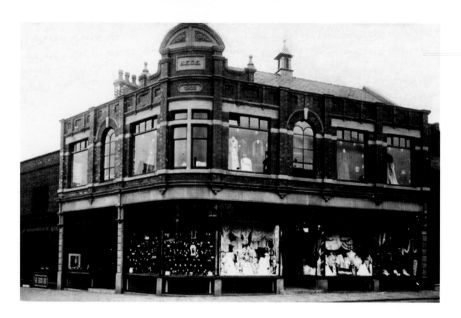

Hyde Equitable Co-op

Above: Pictured around 1910, the Hyde Equitable Co-op stood on the corner of Queen Street and Market Street. Hyde had a Co-op shop in 1838, but they were known as Union or Brighton shops. Surplus money from the non-profit making businesses was distributed among the members of the Co-operative and they were encouraged to save by leaving their dividend in the businesses as shares, on which interest was paid. Hyde's own Co-operative Society was established in 1862, as a result of the cotton famine caused by the American Civil War. Out of a population of 50,000, just over 3,000 were in work. This particular branch was opened in 1908. Alongside the Co-ops were stables, laundries, warehouses, an abattoir and even a farm. *Below*: The building still stands practically unaltered in September 2012, but is now a shop specialising in carpets and curtains. Queen Street, however, has not escaped. It is now a mere 40 or 50 metres long and instead of going straight through to Lumn Road it stops at the new Greenfield School.

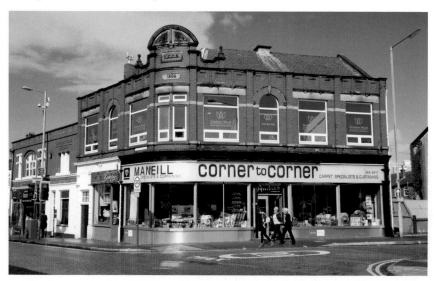

James North Mill

Above: The James North Mill on Queen Street just before demolition in the late 1980s. North's opened as a chamois leather firm in 1876, in a disused stable on Robert Street. When they moved into glove-making, larger premises were needed so they transferred to Godley Mills and eventually Slack Mill on Queen Street. Their greatest claim to fame came when they were asked to supply gauntlets for Shackleton's Imperial Trans-Antarctic Expedition 1914. The view below was taken in 2012 from the Lumn Road end. It is now Douglas Street and there is nothing left to connect the two scenes – everything was swept away to create new houses and the new Greenfield School. The car is parked roughly where the front doors of the new house is in the lower picture. An old direction sign from the 1930s that still bears the Hyde Corporation name is at the junction of the old Queen Street and Lumn Road.

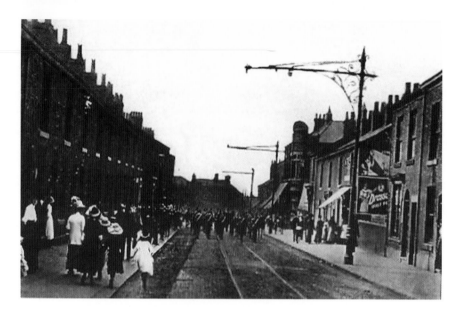

Market Street, *c.* 1912

Above: This section of road, between Queen Street and the Ring O'Bells, had a variety of names including Hyde Lane and Stockport Road, but is now officially Market Street. As most people are dressed in their finery it is possibly a Whit Sunday and the Boys' Brigade are marching back to Zion chapel to be dismissed. Linking the two pictures is the decorative pediment on the top of the Co-op building. In the far distance the Shepherd's Call public house is visible, along with a large building with three chimneys on the corner of Tower Street. *Below*: All the houses on the right have been demolished. For many years NTA Printers was based here, but it is now the location of Ricky Hatton's gym. The houses on the left survive but a few were demolished in the 1920s to make way for Dowson Road. In the distance the Shepherd's Call and the large building survive, albeit a couple of chimneys.

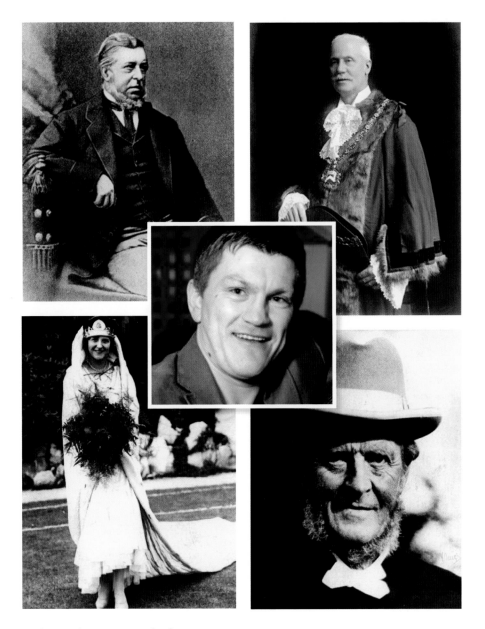

Hyde People To Be Proud Of

Top left: Thomas Ashton junior (1808–98) became Hyde's first mayor in 1881. He successfully ran his father's three cotton mills with his brother and they succeeded in keeping the mills open during the cotton famine caused by the American Civil War. *Top right*: Thomas Middleton JP. Author of *The History of Hyde* and *The Annals of Hyde*, Middleton was mayor of Hyde in 1937. *Bottom right*: The Revd Henry Enfield Dowson BA, Minister of Hyde Chapel from 1867 to 1917. He administered the church for the last twenty years of his tenure without a stipend. *Bottom left*: Francis Lockett, the first Cotton Queen in 1930, worked as a weaver at Ashton Brother's Carrfield Mill. *Centre*: Ricky (The Hitman) Hatton, WBA light welterweight champion in 2005 and *The Ring Magazine*'s Fighter of the Year, and also WBA welterweight world champion in 2006. He retired in 2009 and opened his own gym in Hyde, but he is talking about staging a comeback.

Hyde People To Forget

Wardle Brook Avenue, on the Hattersley estate, is just over a mile from Hyde town centre. It was where Ian Brady and Myra Hindley lived, and where the pair became known as the 'Moors Murderers'. Five children were murdered by this pair between July 1963 and October 1965, two of them at Wardle Brook Avenue, in crimes that Emlyn Williams described in his book of the same name, as 'beyond belief'. The house, which was at the end of this row, was demolished to avoid ghouls from the past visiting it.

Dr Harold Shipman GP was a family doctor in Hyde who, in January 2000, was convicted of the murders of fifteen of his patients by administering lethal doses of diamorphine. He was also convicted of altering the will of his last patient, Kathleen Grundy. He was the first British doctor to be found guilty of murdering a patient. A later inquiry came to the conclusion that Shipman was responsible for over 250 deaths, making him the most prolific serial killer in history. Shipman hung himself in Wakefield Prison in 2004.

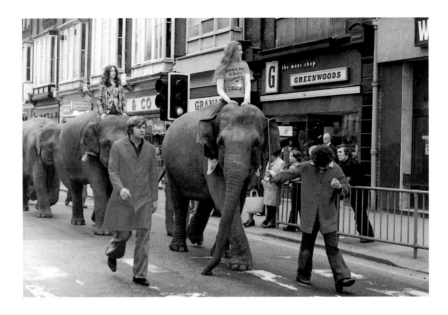

A Hyde Long Gone I

Above: The next three pages are not 'then and now' comparisons, but rare pictures of a Hyde long gone. When did you last see elephants parading down Market Street? They are pictured here in 1974, when the Roberts Brothers' Circus came to town. Remember Greenwoods, Granada, Byles, Greggs, Hardy's Furnishers and William and Glynn? *Below*: Bo-Bo electric loco No. 76001, built at Gorton, speeds through the old Godley station in 1979 with a parcel train bound for Sheffield. The Wall's factory is in the background and coal hoppers are stabled in the factory sidings.

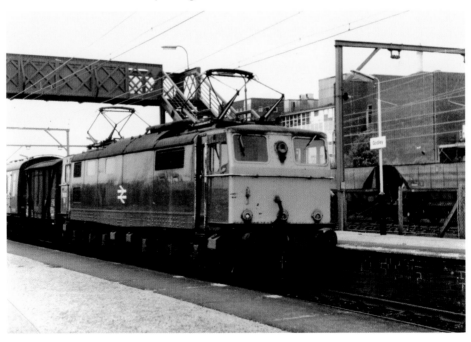

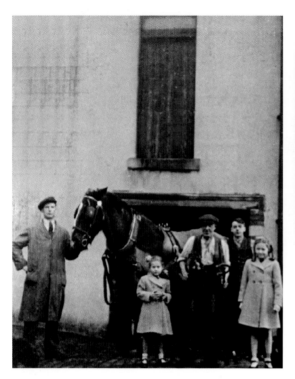

A Hyde Long Gone II

Above left: The smithy, around 1948. I think this is the smithy mentioned in the description of the Ring O'Bells, which was situated at the end of the row of cottages that included the pub, on Stockport Road. *Above right*: The Victorian bus shelters opposite the Town Hall are a cherished Hyde fixture and are seen here enhanced by the Christmas lights of 1990. *Bottom right*: Fixed to the wall of the White Lion on Market Place is this plaque dedicated to the founding of Hyde United Football Club in 1885. The town team still holds the record for the highest score in an FA Cup match ... unfortunately it was one they lost, 26-0 to Preston North End in an FA Cup tie in 1887. *Bottom left:* Photographed in 1975 is a board fitted to an upstairs window with an advertisement for BSA Cycles from the 1930s. It was a well-known fixture at the end of Nelson Street until well into the 1990s. The actual shop was round the corner on Market Street and sold bicycles for many years until diversifying into lawnmowers.

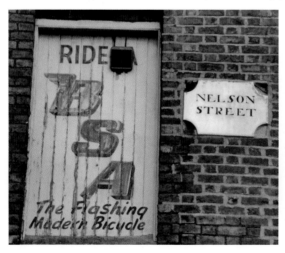
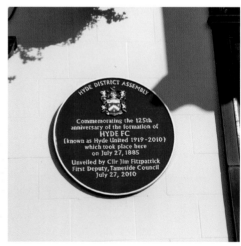

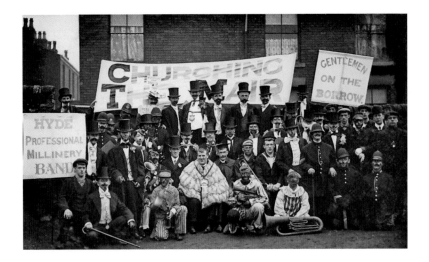

The Forty Gang I

The Forty Gang pose in the council yard on Tanner Street, around 1912. The Forty Gang was a group of Hyde sportsmen, athletes, footballers, boxers and keep-fit fanatics who banded together prior to the First World War for friendship. They will be remembered primarily for their comic interpretation of 'A Day At The Races', and The Derby seems to be the theme for the lower picture. The performance came at the end of Hyde Wakes Week, when the carnival parade was over and awards were given for the best comic, fancy dress, jazz band, morris dancers and horse and dray. Then the Forty Gang would invite everyone to 'A Day At The Races'. They dressed as bookmakers, tic-tac men, jockeys and race officials. The jockeys wore colourful shirts; their horses were fashioned from wooden barrels with horse's heads nailed to them – not always in the right place! Cloth was draped over the barrel and each horse clearly sported its name. The barrels were then hung over the jockey's shoulders. The racetrack was clearly marked out and odds were given and changed according to bets placed. The race would be run in pantomime fashion and somehow there would be a winner and two runner-ups. Winners would be paid and all profits were donated to local charities. Many of the Forty Gang joined the forces together at the start of the First World War and two well-known Hyde heroes were Private Joseph Broadhurst of Elizabeth Street and Private Tucker of Foundry Street.

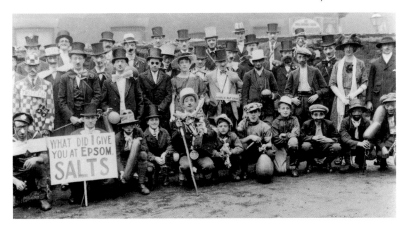

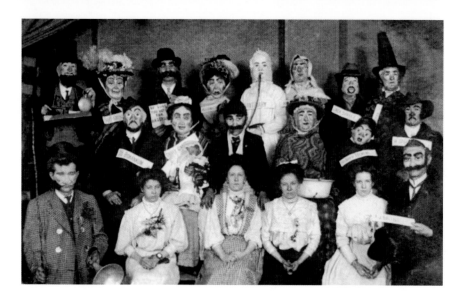

The Forty Gang II

Above: Hydonians seemed to have a mania for dressing up and here we see the Forty Gang again. The theme this time is Professor Swankham's Circus. The men have made a lot of effort, but it's quite apparent the ladies are not amused! *Below*: The ladies of the area did their bit while the men were fighting in the war and here we see six of them from Best Hill Mill in Broadbottom, which turned over to munitions during the war, around 1916.

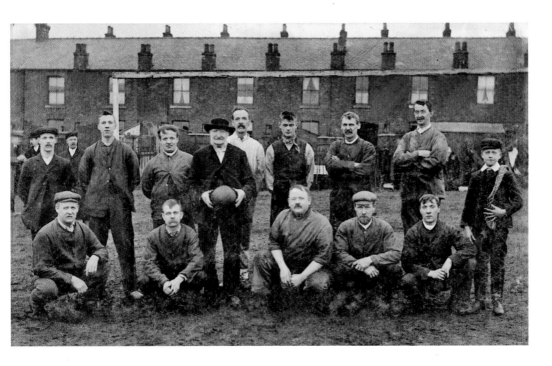

Hyde Football Team, c. 1910

Above: An unknown Hyde football team pose for the cameraman, on what could be Walker Lane. I wonder how present-day footballers would cope with the ball the old chap is holding! *Below*: The visiting French water polo team, in town to play the all conquering Hyde Seals, are given a grand civic welcome in front of Hyde Town Hall in 1910.

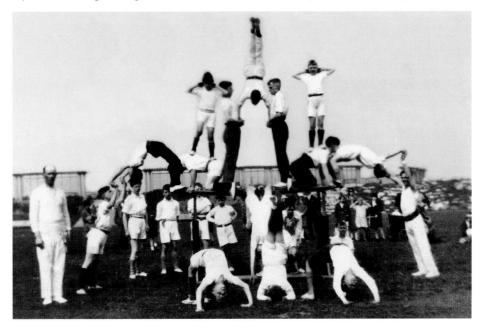

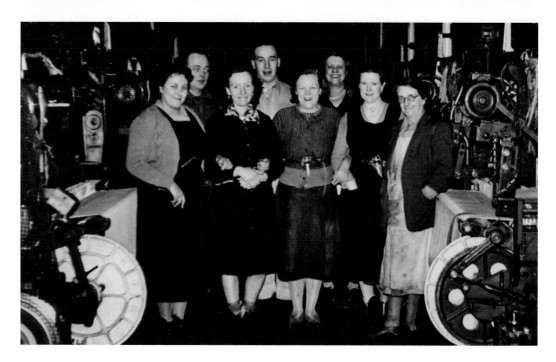

Weavers From Carrfield Mill, *c.* 1947

Above: A group of weavers from Carrfield Mill, including, second from the right, my mother-in-law Annie Braithwaite. She worked at Carrfield Mill for forty-seven years, from 1923 when she was eleven to 1970. *Below*: Dignitaries, players and their families gather at Pole Bank for the opening of Hyde Cricket Club's new pavilion in July 1928.

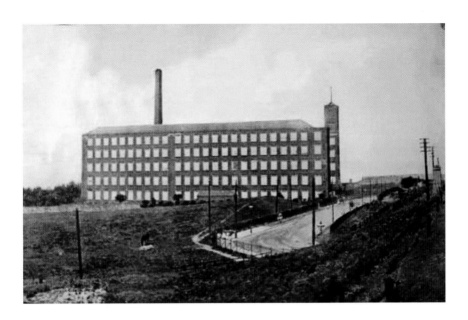

Throstle Bank Mill

Above: Throstle Bank Mill, Dukinfield Road, was an Ashton Brothers' mill that was actually built by Ashton Brothers' own workforce. When the cotton famine hit Hyde, Thomas Ashton came up with the idea of keeping the workforce in employment by building another mill. This they did between 1861 and 1865 and they even used bricks made by the company! *Below*: Carrfield Mill, Newton Street – a shot I took when they were still working the night shift in 1981, although by now they had been taken over by Christy's. This photograph is of the rear of the mill from Park Road. In their heyday the three main mills, Carrfield, Bayley Field and Throstle Bank, had 2,200 looms, 114,580 spindles, 12/328 twist and 1011/5011 weft.

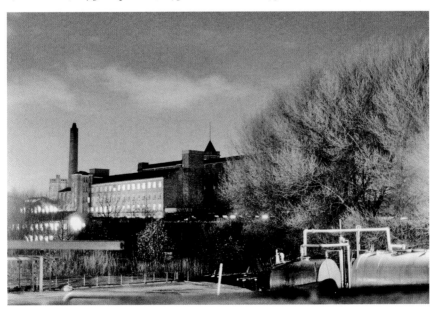

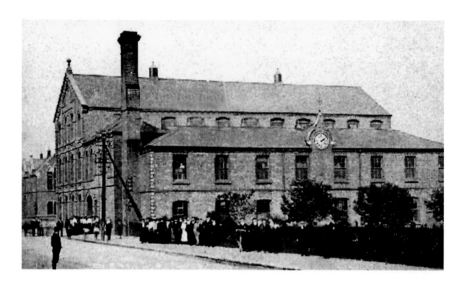

Slack Mills

Above: Slack Mills, Hyde Lane (later Market Street), was a popular mill as it was in easy reach of Hyde town centre. It covered a vast area stretching back from Hyde Lane to Lumn Road and north across Queen Street practically to Nelson Street. At its peak in 1891 it had 1,200 looms, 58,892 spindles, 88/408 twist and 108/501 weft. It specialised in domestics, shirting, sheetings, drills, printers and oatmeal cloths. I have fond memories of Slack Mills as I worked here in the seventies installing a new gas system when it was owned by James North and making industrial gloves.

Below: Hyde Mill, better known to locals as Pattreiouex or Senior Service on Ashton Road. The site was acquired by The Hyde Spinning Co. Ltd from the trustees of C. J. Ashton at a rent of £10 per annum. The building was designed by architect Sidney Scott and finished in 1906, and was the last mill to be built in Hyde. It was faced with bright red brick, had striking windows and an Italianate style water tower in the south-west corner. It was four storeys high and forty-seven bays in length; at its peak it had 116,532 mule spindles. It closed in 1958 with a loss of 250 jobs and the building was sold to J. A. Pattreiouex. The Gallagher group purchased the mill in 1959 for £110,000 and produced Senior Service cigarettes for forty years until they transferred production to Northern Ireland in 1999 and the mill closed. It was demolished in 2009 and a new housing estate called Cotton Mills has replaced it.

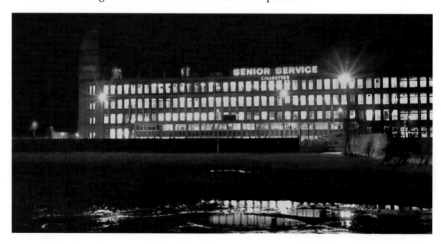

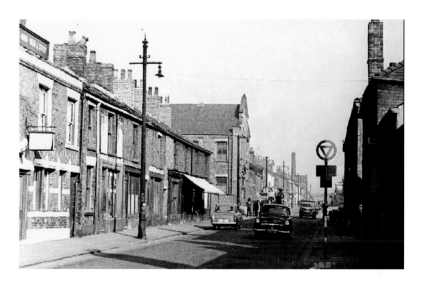

The Spinners, George Street, *c.* 1960

Above: The photographer today would be standing on the eastbound fast lane of the M67, which now bisects the town. The building of the motorway is why the Spinners and everything else in this view disappeared in 1975. The Spinners was lively but could be a little rough. Many times I had to avoid a fight that had spilled out onto the pavement when I was walking up George Street on my way home to Denton after visiting my girlfriend. For the motoring enthusiasts, we have a Ford Consul, a Ford Anglia 100E, a Morris Oxford and a Series 1 Land Rover. *Below*: The Globe, seen here around 1977, at the junction of Walker Lane and Lumn Road, dates back to 1837 when the first landlord was George Healey. In 1844 an enterprising chap called Isaac Booth bought a plot of land behind the Globe and built Hyde's first gasworks there. It consisted of 2 by 350,000 cubic feet gasholders and he sold gas at 7s per 1,000 cubic feet. It lasted until 1855 when he sold out to the Hyde Gas Company on Raglan Street. The Globe closed its doors for the last time in 2010 and has now been completely rebuilt as private dwellings. In the seventies I played the odd game of football for Hyde St Georges on Walker Lane. There were no changing facilities on the ground so we used to change in the backyard of the Globe and after the game we would wash as best we could in a large barrel of water, much to the amusement of the local girls peeping through cracks in the wooden gates!

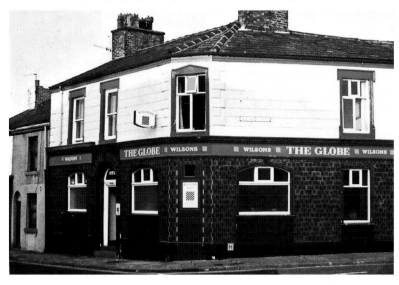

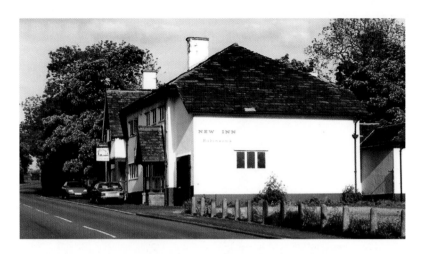

The New Inn & The Hyde Away

Above: The New Inn on Mottram Road, pictured around 1980, dates back to 1856 but was probably a farmhouse before that. One of the most notable landlords in the early years was Sam Swann. Well known in the area, he was reputed to be the strongest man in Cheshire. He was literally a 'giant', with an enormous chest measurement. He could grasp a pint pot in one hand and crush it to fragments with his grip. Hyde boxer Ricky Hatton's parents looked after the pub in the early 1990s and Ricky had a gym built in the cellar. The pub was reputed to have a ghost (a cleaning lady) and on the A57 outside a 'phantom lorry' was seen on many occasions. The pub closed around 2010 and is currently being converted into living accommodation – new occupants beware! *Below*: The Hyde Away, pictured around 1987, at the junction of Manchester Road and Clarke Way. It was previously the Red Lion and it opened in 1857 as a beerhouse. In 1910 the landlord was George Webb and he ran the pub until his death in 1939 when his son Herbert took over. Herbert died in 1971 and left £6,000 and instructions to provide the old folks of Hyde with an annual party until the money ran out. It is rumoured that the pensioners drank that much at that first party that the money ran out in 1972. Only joking!

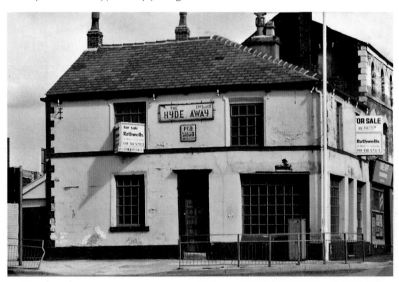

St John's & Holy Trinity

Above: St John's, Godley, pictured around 1920. Prior to 1850 Godley was in the parish of Mottram and villagers wishing to attend church had to walk to St Michael's at Mottram. St John's was consecrated in 1850 and the first minister was the Revd R. K. Bateson.
Below: Holy Trinity, Gee Cross, was in 1874 a chapel of Hyde St George's and it wasn't until the new townships of Hyde and Werneth were created in 1880 that it became the district church for Werneth. The first minister was the Revd Thomas Bourke. The church is pictured prior to the new tower and clock being added in 1904–06.

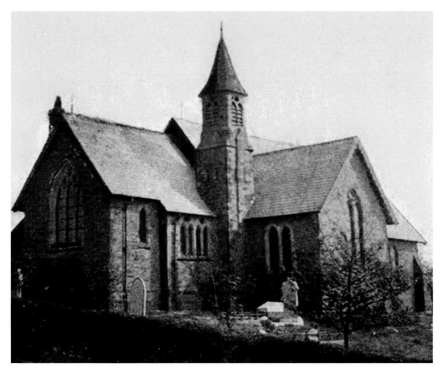

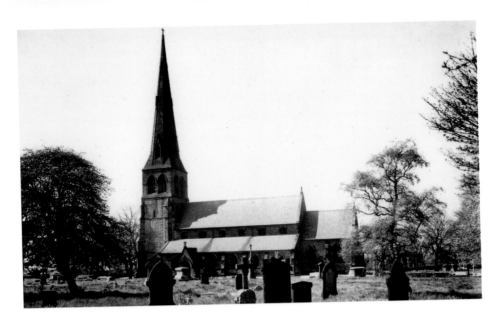

Hyde Chapel & St Thomas'

Above: Hyde chapel, Gee Cross. There was a church on the site of the present Hyde chapel in 1708 but the present church dates from 1846. It was the first Nonconformist place of worship in England to be built as a copy of a medieval parish church, with stained glass and a stone altar. Beatrix Potter's mother and aunt were both married here in 1863 and 1862 respectively, with Revd Charles Beard officiating. The Revd H. E. Dowson BA was minister from 1867 to 1917. *Below*: The church where I was married in 1971 was St Thomas', Lumn Road. Pictured here in 1912, it was designed by Manchester architect Medland Taylor, who also designed St Anne's in Denton, St Mary's at Haughton Green and Holy Trinity at Gee Cross. St Thomas's was described as an example of Taylor's humour by Pevsner, with the roof having an additional pitch to it. The church's crowning glory is its William Morris windows. The first minister was Revd A. Read.

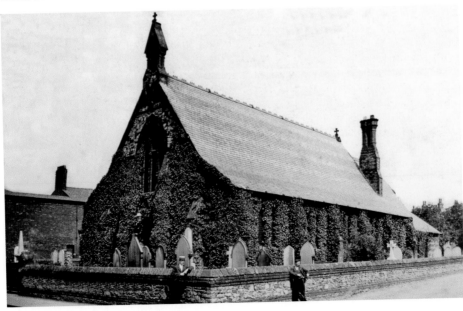

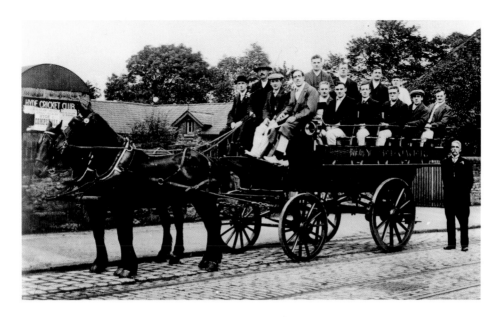

Hyde Cricket Club

Above: Hyde Cricket Club's second eleven aboard a wagonette at Pole Bank on Saturday 18 July 1914, about to set off for a game at Compstall. Nearest the camera on the front seat is one of Hyde's greatest all-rounders, Joe Higginbotham, who became the club's first Honorary Life Member. The farm in the background is Bagshaw's and Hyde's ground was beyond the barn and trees in the background. The wagonette, named *May Flower*, is standing where the lamp post is in the photograph on page 6. *Below:* Steam returned to Hyde in 1977, as ex LMS Jubilee 4-6-0 Class 6P No. (4)5690 *Leander*, passed through Hyde Central Station with a special train for Buxton.

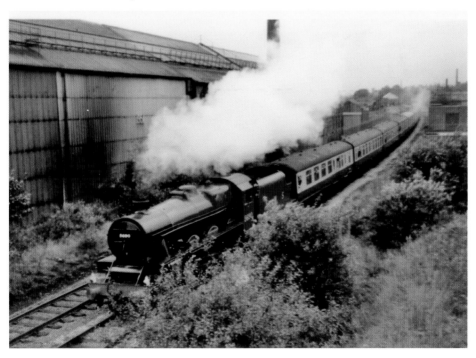

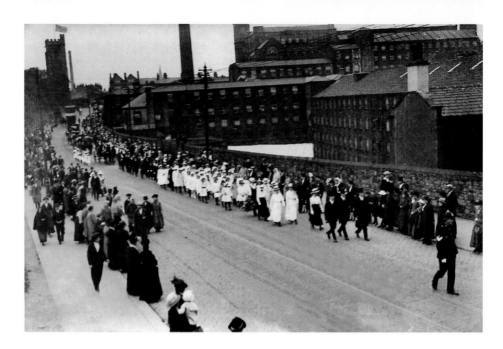

Ivy Wood

The murder and rape of thirteen-year-old Ivy Wood is famous in the annals of Hyde history and here we see her funeral procession passing Ashton Brothers' Carrfield Mill on Newton Street. It was in this very mill where the poor girl tragically met her end in 1919. The man convicted, nightwatchman Arthur Beard, later had the charge reduced to manslaughter on appeal ... because he was drunk! That decision was later overturned by the Lord High Justice but he escaped the hangman's noose. You can see a memorial to Ivy in Hyde cemetery. In the view below, from July 2012, most of the mill has been demolished and a housing estate stands where once the loom and shuttle sped. Christy's, who took over Ashton Brothers, still maintain a shop and some offices here. The building with a sloping roof and Flowery Field church, just visible through the trees, link the two pictures. *Inset*: Ivy Wood in 1916.

Lodge Lane, Newton, c. 1910

Above: When this photograph was taken the houses would not have been up very long as they do not appear on the 1871 map. From the junction with Newton Street there were allotments on the left and a park with a bowling green and a lake on the right. Hydonians must have loved their chocolate as both Cadbury's and Fry's advertisements can be seen on the corner shop. *Below*: Even the corner shop is still there! It is August 2012 and incredibly hardly anything has changed. If the parked cars weren't there you would see the walls are mostly still as they were. I went back to this location time after time to see if I could get a shot without the cars but they never seemed to move.

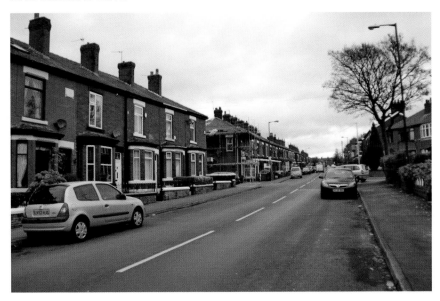

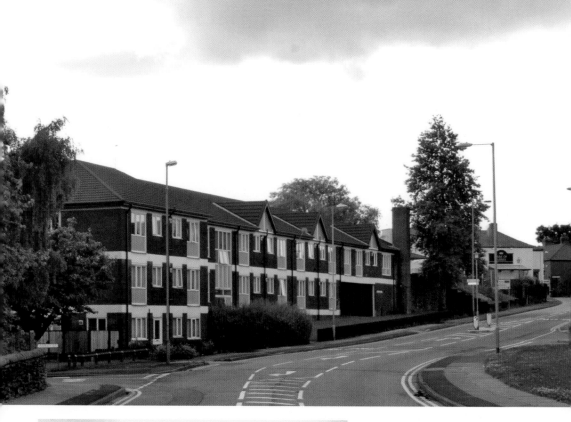

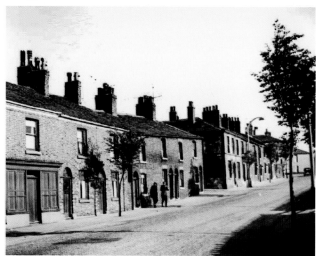

Ashton Road

Left: Pictured here is Ashton Road, Newton, looking up to the Duke of Sussex public house, around 1960. All of the houses on the left were swept away not long after this photograph was taken and, as can be seen above, a residential home now stands in their place. Only the Duke of Sussex at the top remains to link the two photographs. Garden Street playing fields are behind the houses and a new housing estate is opposite, where for many years a scrapyard existed.

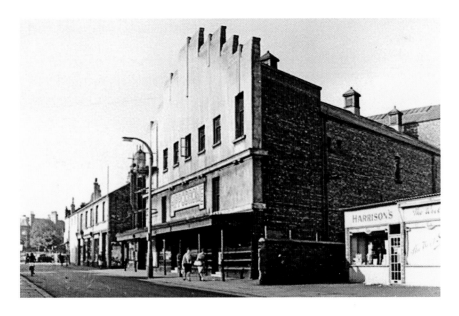

The Hippodrome I

The Hippodrome, Clarendon Street, pictured here around 1955, was officially named the Hyde Hippodrome & Opera House. It was built by local man Wilbraham Stansfield and opened in September 1914 to a design based on the Tivoli Theatre in Manchester. Next to the theatre Harrison's sweet shop and the Wool Shop are visible. Below Stannies, or the 'Fleapit' as locals knew it, became a cinema after the First World War and it was the first Hyde cinema to show a 'talkie'. The Hippodrome closed in 1960; the last film shown was *Frankenstein's Daughter*. After renovation the building began a new life as a supermarket in 1961, opened by Morecambe & Wise, Freddy Frinton and Alma Cogan. Now don't start asking who they were! I was a regular visitor to the supermarket as upstairs was Hubble's record shop, a decent bookshop and a lady who specialised in clothing repairs and alterations. My abiding memory is browsing books or records while listening to the Bingo going on at the far end.

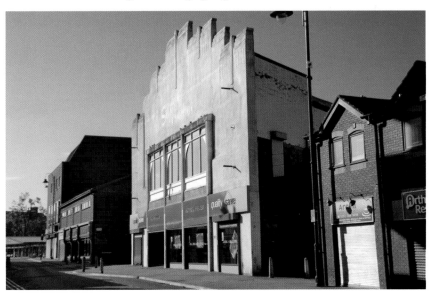

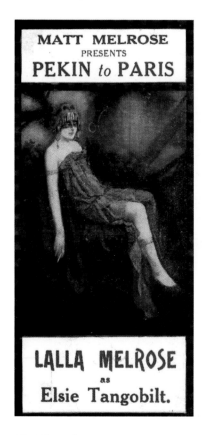

MATT MELROSE
PRESENTS
PEKIN *to* PARIS

LALLA MELROSE
as
Elsie Tangobilt.

The Hippodrome II

Lalla Melrose was visiting Hyde around 1916, but unfortunately I couldn't find out a thing about *Miss Melrose* or *Pekin to Paris* (a ticket for Matt Melrose's production of *Pekin to Paris* at the Hippodrome can be seen above). Gracie Fields and Archie Pitt are also pictured (*below*). Archie was a Cockney comedian and impresario, who first became Gracie's manager and then her husband in 1923. Bet he went down well in 'Eyde! They divorced in 1939. On the far side of the Hippodrome and running its full length to Market Street is the Borough Arcade. In the photograph below, from around 1950, we can see two little girls standing by a shop window. I hope Daddy's not left them while he's playing billiards! The arcade still stands today but the billiard hall is now a gym.

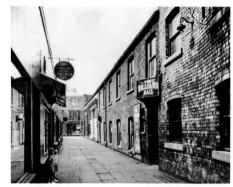

Creese's Ales and Stouts

The white factory is Creese's Brewery on Cheapside at the junction of Hoviley, with Randal Street just behind, around 1950. The brewery was initially a bottling plant, but Charles Creece decided to extend the business and brew his own brand of beer. The first brew of beer at Cheapside took place in April 1905. As the business grew and trade steadily expanded the brewery added further varieties to its range, which included an 'Owd Bill Strong Ale', an 'Oatmeal Stout' and what would become their renowned bottled 'Pale Ale'. Creese's ales and stouts were bottled and sold by other companies, from Redditch to Arbroath. Due to the amount of beer being produced, a constant supply of fresh water was required for the process and the town's own water supply was found to be inadequate as it had to be treated to satisfy the requirements. To overcome this problem Charles Creece had a well sunk in the brewery premises at the junction of Brooke Street and Randall Street, from which 6,000–7,000 gallons of water were pumped every hour when the brewing process was under way. As a public relations exercise Charles Creece opened up the brewery to public visits, where the mysteries of beer manufacture were explained by a knowledgeable member of staff. When he eventually sold his business in 1929 to the Salford brewers Walker & Homfreys, it included sixty-six licensed public houses. He later returned to brewing when he formed a company called British Malt Yeast Ltd, which manufactured liquid malt extract at the Cheapside premises. It was impossible to get a photograph of a modern-day view as everything in the 1912 photograph was swept away for the building of the M67.

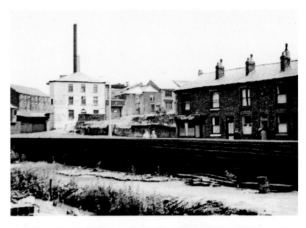

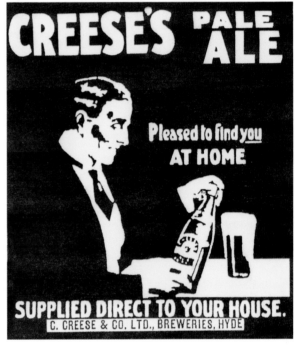

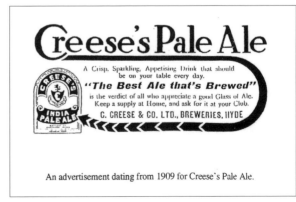

An advertisement dating from 1909 for Creese's Pale Ale.

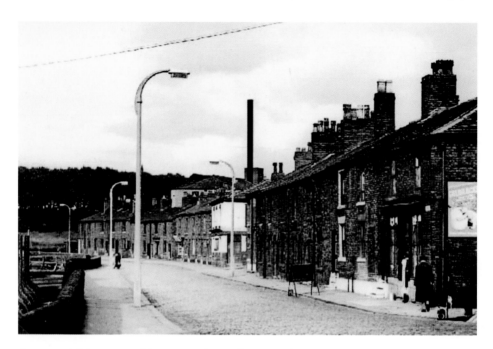

Commercial Street, Looking Towards Hoviley, c. 1960

Above: The street was originally called Ashton Road and the row of terraces on the right were called Sixteen Row. Godley Brook on the left is becoming more than a brook by this stage of its journey to the River Tame and it was the main cause of the devastating floods of 1906 that caused so much damage in the Hoviley area. *Below*: In the view from September 2012 the houses on the right have all been replaced by modern dwellings and nature has been left unchecked on the left. The M67 motorway is just over the trees on the left.

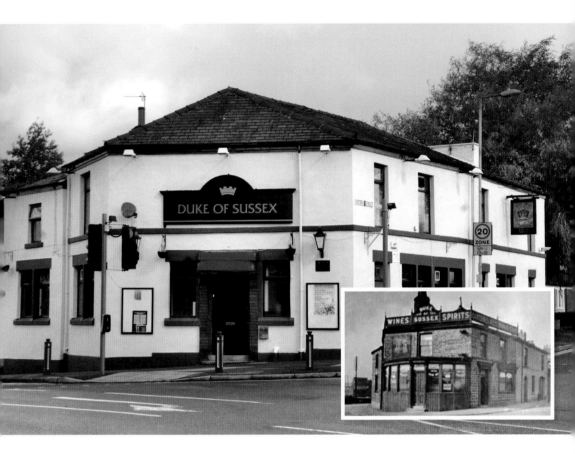

The Duke of Sussex, Ashton Road, Newton, *c.* 1920

The Duke, as it is known by locals, is named after the Duke of Sussex, who owned large tracts of land in Newton and the surrounding areas. Originally an alehouse that began selling beer in 1828, the shop next door was incorporated into the pub in 1858 by the landlord John Harrison. The upstairs windows on the right, the Victoria Street side of the pub, are all that look the same in this view of the Duke in September 2012.

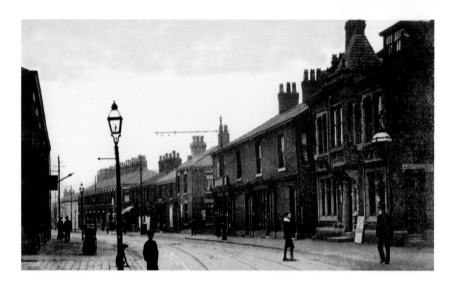

Mottram Road

Above: Mottram Road is pictured here at the junction with Lumn Street (later Lumn Road) and Cheapside, around 1910. The Sportsman public house on the right opened in 1838 and the first landlord was John Shepley of the Shepley family from Lumn Farm. John Shepley Street is named after him. The Sportsman became popular when the roads improved and it welcomed a roaring trade with people travelling over the Pennines. In the photograph below, from July 2012, the Sportsman is still there, but now specialises in Cuban tapas food. The short row of houses adjacent also survives, but the rest, including the Turbine Garage, Bowker Street and Lewis Street where, the tram sheds were situated, were demolished to make way for the M67 and the Fine Fare supermarket. The houses opposite, including Pomeroy's junk shop, were demolished somewhat later, but the Moulders public house survives. It was named from the engineering works that once stood across Mottram Road, but for some strange reason has been renamed the House At Home. I went in to Pomeroy's one day for a browse to pass half an hour or so. I'd been in the shop for a good fifteen minutes thinking that John must be upstairs or in the kitchen. I picked something up with a view to possibly buying it and almost jumped out of my skin as a voice said, 'Nah then, that'll be three an' six.' All the time I had been in the shop he had been sat amongst the junk, completely invisible!

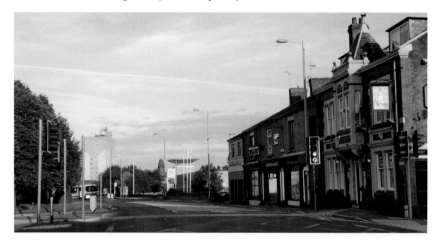

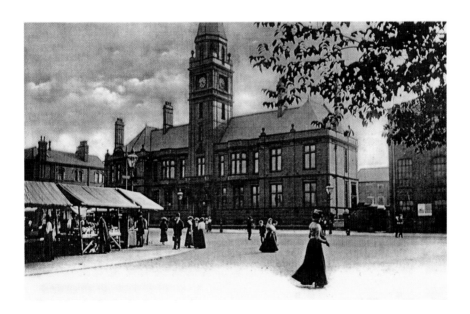

Hyde Town Hall, *c.* 1900

Above: The building was erected in 1883/84 at a cost of £10,000 and the foundation stone was laid by Mr Thomas Ashton, the first mayor of Hyde. It was opened by the second mayor, Mr Edward Hibbert, and the clock and bells were generously donated by Mr Joshua Bradley, a retired spinner, who for some years had occupied a seat on the council. Under the foundation stone the mayor inserted a tin box that contained a copy of the Charter, an abstract of the accounts from the previous year, a list of councillors and officers of the borough, copies of local newspapers and some coins of the realm. Greenfield Mill can be seen on the right and the building behind the Town Hall is also part of the mill. *Below*: The mill has disappeared and the Town Hall was extended to incorporate more offices and the police station, as can be seen in this view from 2012. The market was also extended into the junction and has just received a costly makeover in an attempt to entice shoppers back.

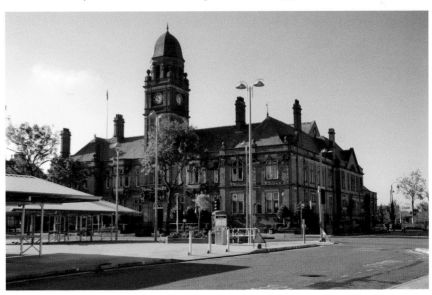

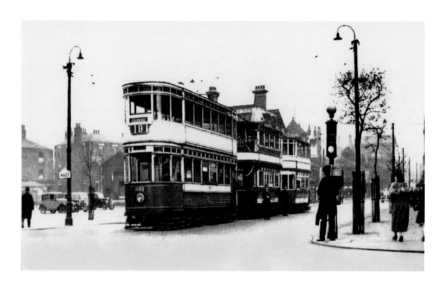

Town Hall Terminus

Manchester Corporation tram No. 561 on service 19 to Manchester Exchange, waits for its departure time outside the Town Hall terminus, around 1930. Behind are a SHMD 'Green Linnet' and a Stockport Corporation tram on the Hyde to Stockport Edgeley via Gee Cross service. Across the Market Place the Norfolk Arms Hotel is visible and an Austin 7 and a Morris 8 are parked. A great tragedy occurred at the Norfolk Hotel in April 1828. It was at a time when trade was severely depressed and mill owners and masters were reducing wages. This was most resolutely denounced by the workers and a meeting to protest was held at the Norfolk. The organisers had expected a turnout of 300 but over 600 people attended and in the course of proceedings the floor suddenly gave way. Three hundred persons were thrown into the cellar resulting in twenty-nine deaths. For many years the disaster was referred to as 'May's Downfall', for Mr May was the landlord at the time. In the view below, from July 2012, a new stagecoach, Alexander-Dennis Enviro 400 on the 330 route from Stockport to Ashton-under-Lyne, waits at the lights in almost the same spot as the Manchester tram above. In the background the work to regenerate the market ground is taking place. The twin chimney stacks of the Midland (HSBC) Bank building can still be seen above the bus.

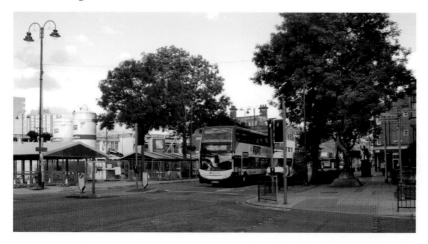

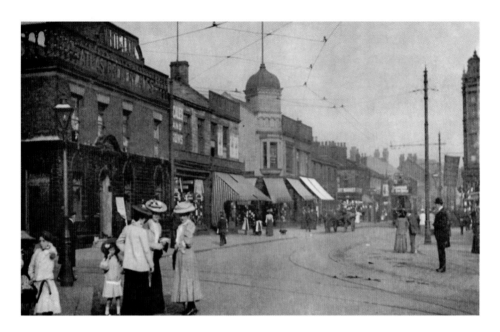

Market Place I

Above: Don't the ladies look elegant in this view of Market Place, around 1910? The White Lion public house is prominent on the corner of Clarendon Street and the Brownson Clothier store in the background. The White Lion was opened in 1840 by Joseph Platt of Newton. The building was demolished around 1890 and the building we see now was built to the design of Kay's Atlas Brewery of Longsight. This company was later taken over by the Robinsons Brewery of Stockport. The Lion has always been the premier Market Place pub for both traders and shoppers and it also boasted that it had the largest and best concert room in Hyde. Next to the pub was Scales & Son, boot and shoe dealer's, and on the corner of Hamnett Street was the Progress Supply Company. *Below*: In the photograph from October 2012 we see that all the buildings on the left survive but everything on the right disappeared in the modernisation plan of the sixties. The façade of the White Lion has changed somewhat but still retains its character and the Brownson tower is a reassuringingly ever present.

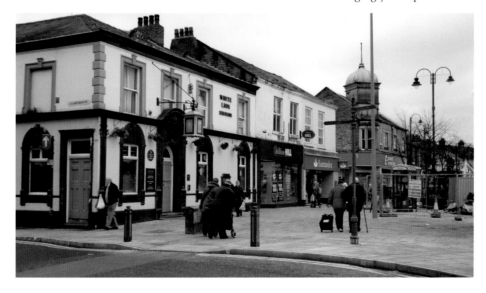

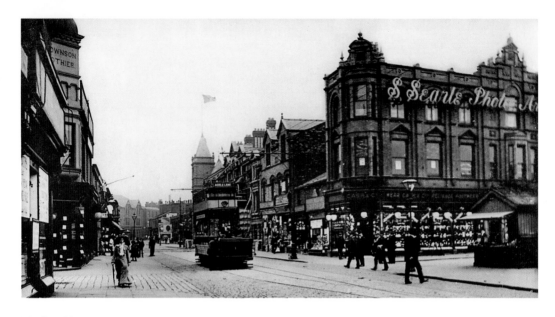

Market Place II

Above: Market Place again but the photographer has moved nearer to the White Lion for a view down the right-hand side. He could possibly be Mr Searle himself from the large store that dominates the picture. Once again the Brownson Clothier store is prominent, and in the distance a flag is flying from the Reform Club and the double front of the Hyde Gas Company's building can be seen. *Below*: The buildings on the left are still there, but nothing on the right survived the modernisation plan of the sixties and the whole row disappeared. I wonder what Mr Searle would have said.

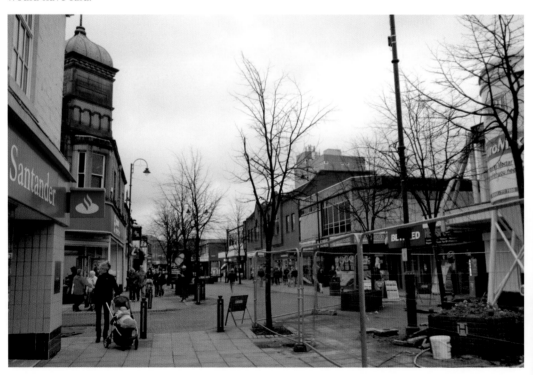

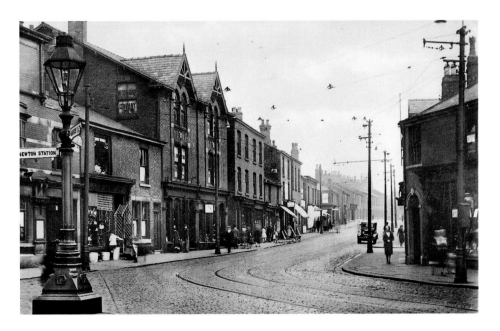

Clarendon Place, c. 1925

Above: It is pleasing to see that the row of buildings from the Queens Hotel on the extreme left to the junction with Mottram Road in the middle distance survive, as can be seen from the photograph below from July 2012. The road has been considerably altered in the intervening years as the bypass, which is hidden by the trees, cut the town in half. Most of the buildings in the far distance, on Ridling Lane, were demolished. The large, double-fronted building belonged to the Hyde Gas Company. The shops on the right were demolished during the modernisation plan of the sixties and replaced by the monstrosity that is the multi-storey car park! The magnificent lamp stood in the centre of the junction and also had signs that indicated the directions to Manchester, Mottram and Newton stations.

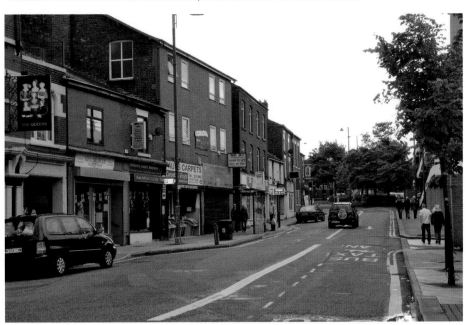

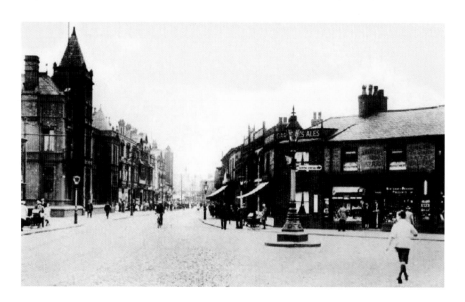

Clarendon Place

Above: Clarendon Place, pictured here from the opposite direction around 1930. The Jolly Carter, selling Gartsides Ales brewed in Manchester, is prominent behind the lamp, as is the Reform Club – the large building with the tower on the opposite side of the road. All the buildings on the right survive today, as can be seen from the view below in July 2012. Every building on the left disappeared in the sixties to be replaced by the Clarendon Shopping Centre or Mall as it became more popularly known.

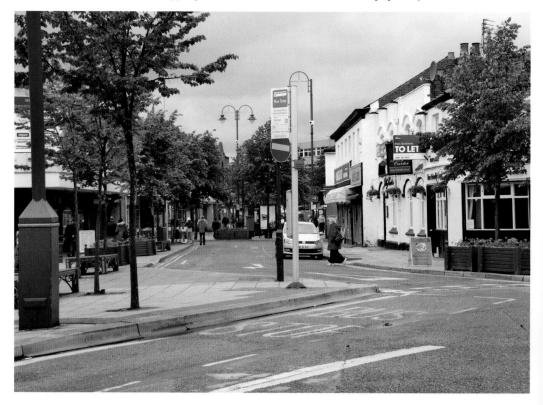

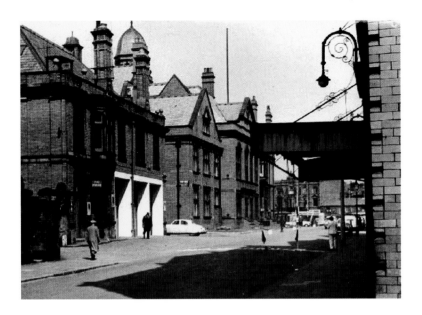

Corporation Street, *c.* 1960

Above: A Jaguar MK10 disappears into Jackson Street. The fire station is on the left with the police station on the opposite corner near to the Town Hall. Across the market ground in the distance the Searle building is visible, which was soon to be demolished as the town-centre regeneration got under way. The canopy of the Theatre Royal is on the immediate right. *Below*: In the view from June 2012, the fire station has gone but little else has changed, until you reach the market ground and come across the Mall ... enough said!

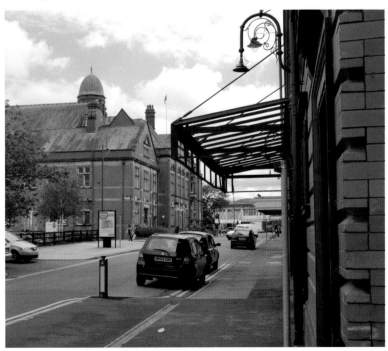

Town Hall Buildings

Above: The town hall buildings are seen here at the corner of Market Street and Corporation Street, around 1950. The shops I have been able to identify include Boots, Greenwoods, Harrops and Prices. *Below*: Except for a pelican crossing replacing a zebra crossing and there being more road markings, little has changed, especially in the upper storeys. What is especially depressing about this photograph is the abundance of shutters at all the windows, not only to deter smash and grabbers but to protect the glass from the Friday and Saturday night drunks. A sad indictment of the times we live in I suppose.

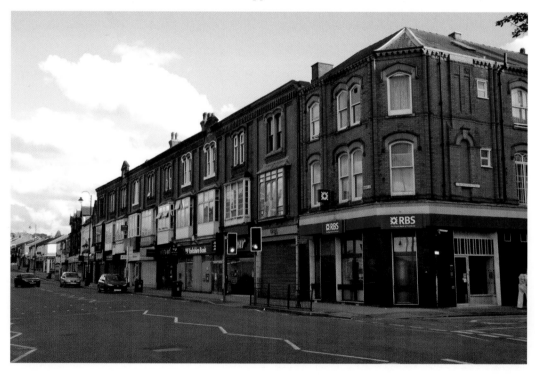

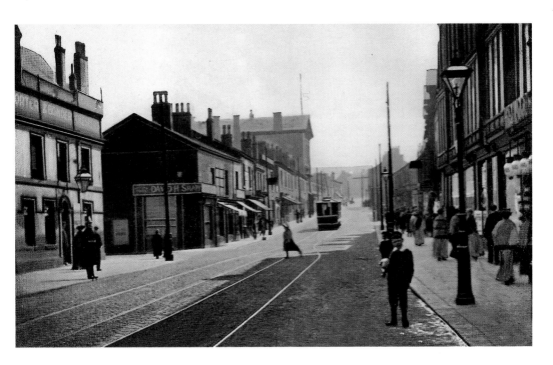

Market Street I

Above: A policeman outside the Clarendon public house keeps a wary eye on the photographer in this view of Market Street from around 1905. A Lowry figure seems to skate across the road as a tram comes down from Gee Cross to the double section of tracks at the Town Hall terminus. The massive bulk of the Mechanics' Institute dominates the middle distance but in the view below, from June 2012, the institute has disappeared. The Conservative Club is now visible over the roof of the renamed Last Orders public house. All the other buildings survive but where did all the chimneys go?

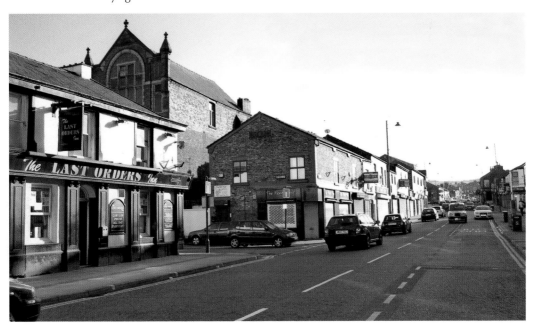

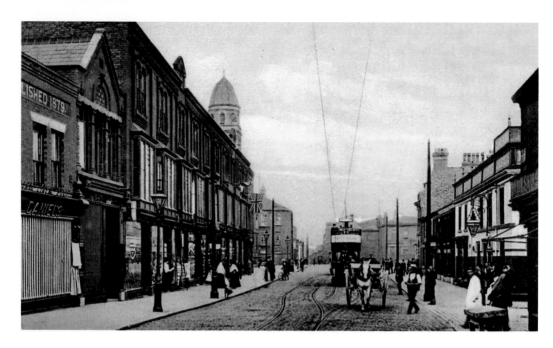

Market Street II

Above: This view of Market Street is from the opposite direction, around 1905. Here we see the Town Hall buildings on the left with the Town Hall tower peeping over the rooftops. Just beyond the Town Hall, Greenfield Mill is visible and the Clarendon public house and Reynold Street are to the right of the horse and cart. Is that a butcher's block at the kerb edge? Surely Wally Ashworth wasn't around then! In the view below, taken at 5 a.m. on 20 June 2012, very little has changed apart from Greenfield Mill disappearing, the addition of a few trees and the renaming of the Clarendon to the Last Orders, which begs the question, why?

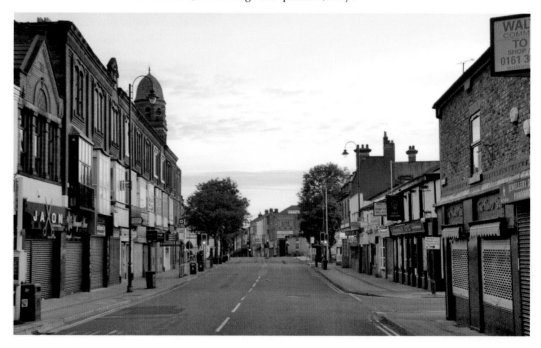

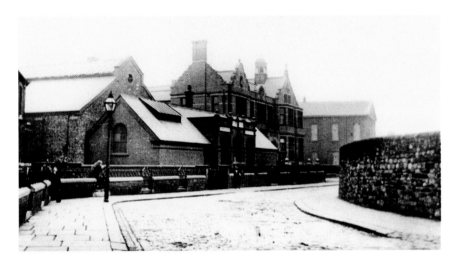

Hyde Free Library and Public Baths, Union Street, c. 1920

Above: The library was opened in 1897 and the baths in 1889. The library still stands but the baths were demolished in the late sixties and replaced by a successful leisure pool on Walker Lane. The baths were famous as the base for Hyde Seals water polo team, who were world champions in 1904/05/06. One of Britain's greatest female swimmers also learned to swim here. Lilian Preece competed at the 1948 London Olympics and captained the Great Britain swimming team four years later in Helsinki. In 1953 she was voted swimmer of the year, when she broke her own 880-yard freestyle record by a staggering fifteen seconds to add to her own 100-yard freestyle record. To the right of the library the large Union Street Congregational church is visible. As seen in the view below, the church was demolished and replaced with a smaller building set back from the road. A car park is situated where the baths used to stand. I have been instructed to tell you my wife learned to swim here and she was also a member of Hyde Seal Swimming Club.

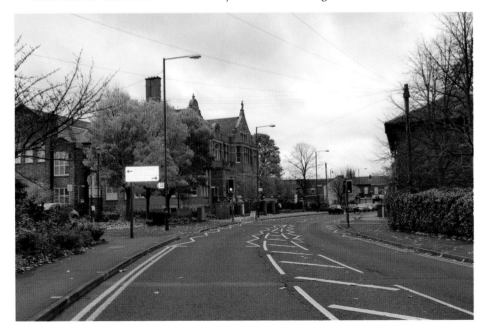

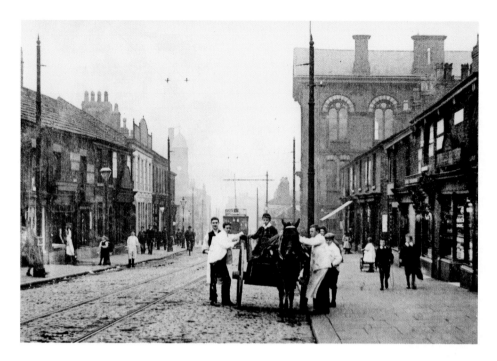

Market Street III

Above: There is so much going on in this view from around 1910. A delivery cart and its attendants pose for the cameraman as a Stockport-bound tram rattles past the imposing Mechanics' Institute on the corner of Union Street. The white façade of the Cheshire Cheese public house is easily identifiable as a man on a bicycle rides serenely down the cobbles. Two boys saunter home from school, one with his hoop in his hand. The Town Hall and the chimney from Greenfield Mill are visible in the background. *Below*: In the view from June 2012, the Mechanics' Institute and Greenfield Mill have gone. The Cheshire Cheese is now an Indian restaurant/fast-food takeaway but the majority of shops survive in one way or another.

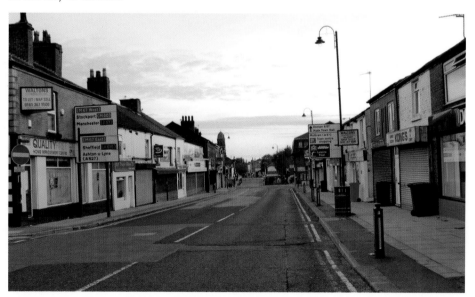

Woodend Lane

Right: A delightful view of Woodend Lane, around 1905, with St George's church in the background. In the photograph above, from July 2012, a gentleman takes an evening stroll, the foliage has run riot and only the brick wall on the left gives any clue that this is the same location.

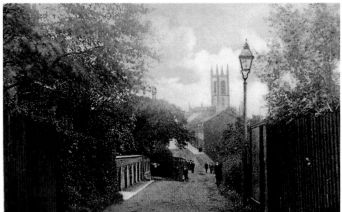

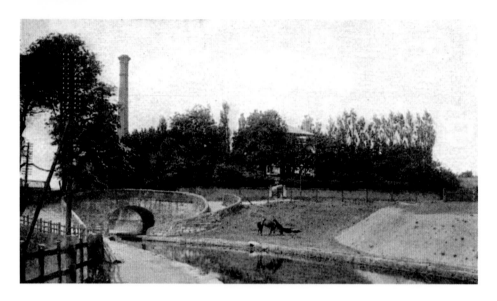

Captain Clarke's Bridge, Woodend Lane, c. 1905

Above: The Clarkes were one of Hyde's most notable families and the head of the family was Lord of the Manor. The family seat was Hyde Hall, which was about half a mile from the bridge down by the River Tame. Hyde John Clarke JP (1777–1857) had been a notable captain in the Royal Navy and when he retired to Hyde he was engaged in the administration of the Ashton and Peak Forest Canals. Prior to moving into Hyde Hall he moved into Wood End House, which is situated just to the left of the bridge. This is probably how the bridge came to change its name from Wood End Bridge to Captain Clarke's Bridge. It is possibly the best known bridge on the canal, being the subject of many postcards, and is known as a 'change bridge', where the towpath switches from the left bank to the right. This was done here at the behest of Hyde John Clarke's father, George Hyde Clarke, who welcomed the cutting of the canal through his land but didn't want the towpath, as he was fearful of trespassers encroaching on his land. The large house visible through the trees is Fern Bank and the chimney is at Providence Mill on Alexander Street. *Below*: Apart from nature being left to run riot, not much has changed in the ensuing 107 years. Fern Bank is still standing but Providence Mill closed many years ago.

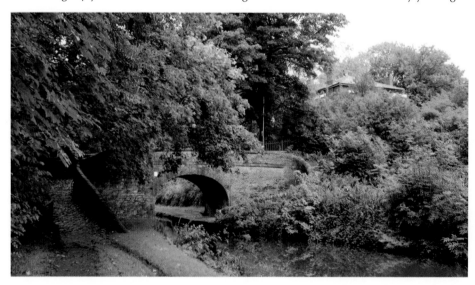

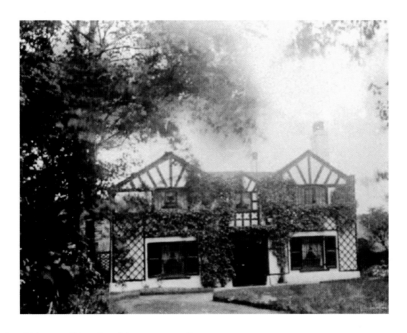

Woodend House, Woodend Lane, c. 1908

Above: The date above the house is 1632 and it is believed that back then it was a farm. It was here where Captain Hyde John Clarke lived for a few years before he moved into Hyde Hall, which was in the valley of the River Tame behind the house. *Below*: In this view from September 2007 the ivy has been cleared, the porch has gone and windows have been altered, but the house and gardens have changed little over the years. The inset shows Captain Hyde John Clarke, from a painting around 1830.

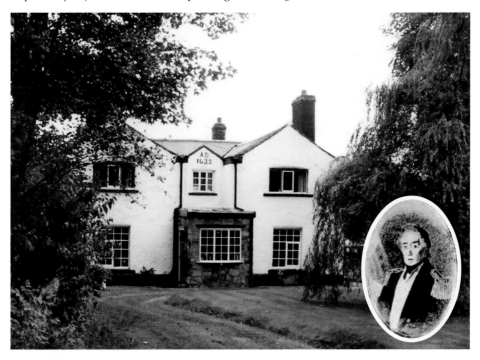

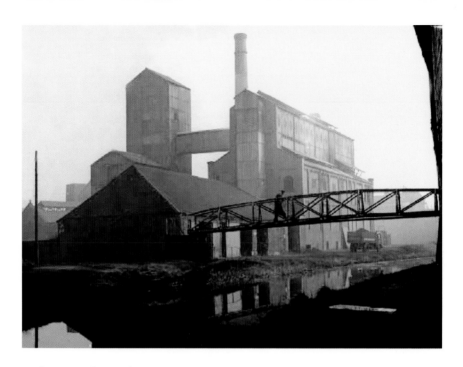

Hyde Gasworks, Raglan Street, *c.* 1930

Above: Hyde Gasworks, at the side of the Peak Forest Canal with the giant retort house standing supreme over the site. In its heyday the works, which took over the site of Millwood Mill, covered a large area on both sides of Raglan Street. It was odd that (to my knowledge) very little coal was delivered by barge, especially as the canal ran alongside the works. It was here that I began my thirty-year career with the North Western Gas Board in 1966. Gas production had ceased some years before but many of the buildings survived and I had a wonderful time exploring. *Below*: How quickly nature reclaims her own. Fortunately in September 2012, an old footbridge and, somehow, a telegraph pole survive, which link the two pictures.

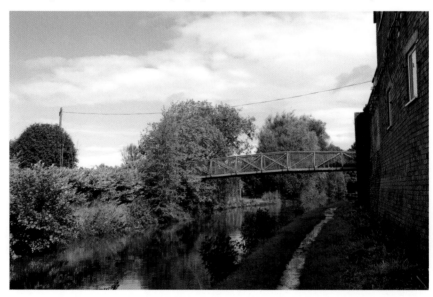

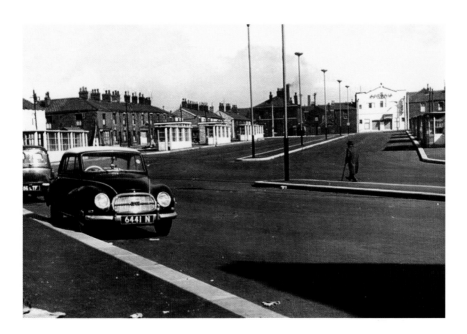

Hyde Bus Station, *c.* 1965

Above: Howard Street, Charles Street and one side of George Street all disappeared to make way for Hyde's new bus station, and here we see it finished and waiting for opening day. A rare Auto Union 1000, which would eventually become Audi, and a Ford Thames 300E van take advantage of free parking. A dapper looking gentleman strolls across, while in the background the Star public house and the Astoria Bingo Hall on Clarendon Street are visible. *Below*: In this view from September 2012 a £3.5 million, 'space-age looking' bus station that opened in 2005 has replaced the old one. On the left all of George Street has gone as the M67 now runs alongside the bus station, bisecting the town. Still standing, although in a somewhat dilapidated condition, is the sadly closed Astoria. I believe there were riots in Hyde as the only bingo hall left in the town shut its doors for the last time!

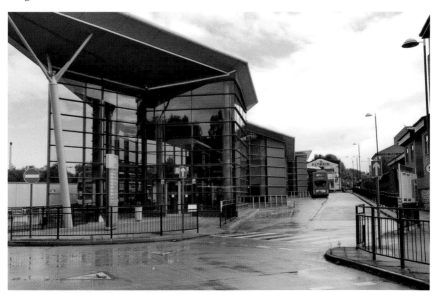

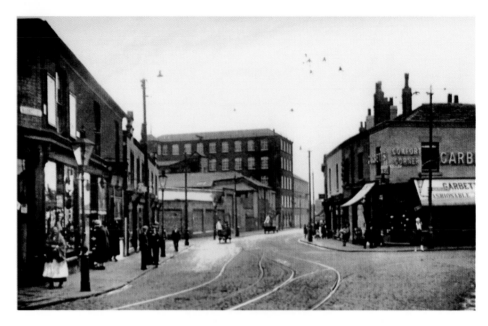

Manchester Road at the Junction with Market Street and Newton Street

Above: It is difficult to put an exact date to this scene, but going off the lady in the white hat and the lorry in the distance outside Greencroft Mill, I would guess at around 1925. Garbetts 'Comfort Corner' shoe shop dominates the corner but, as can be seen in the picture below from July 2012, what was once Newton Street is now a slip road to join the M67 to Denton, and almost everything else in the view from 1920 was swept away to make way for the motorway and the B&Q store.

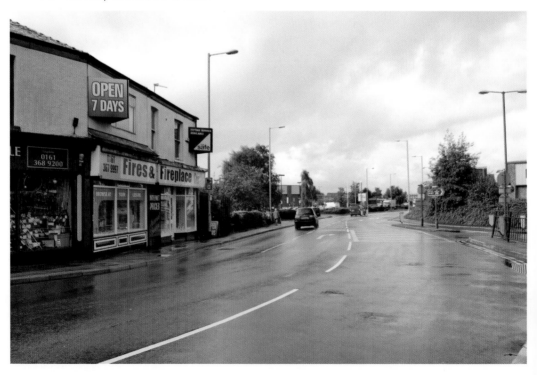

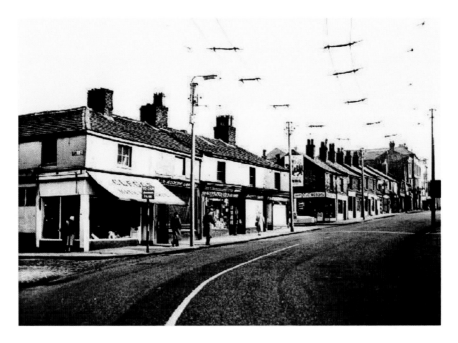

Lower Market Street, Near the Junction with Newton Street, *c.* 1956

Above: The street opposite, with Cleggs shoe shop on the corner, is Charles Street according to the 1897 map. Howard Street is further up with a car spares shop on the corner; a Bond three-wheeler can be seen parked outside. The older row of shops in the middle distance is Ten Houses, which was reputed to be the oldest row of shops in Hyde. In the early sixties most of this row was demolished up to the large gable end visible in the distance. Behind the shops and running as far as George Street, many of the back-to-back terraces were also swept away in the Hyde modernisation plan. *Below*: A row of characterless shops from the sixties sweeps up to the surviving buildings at the top in this view from June 2012.

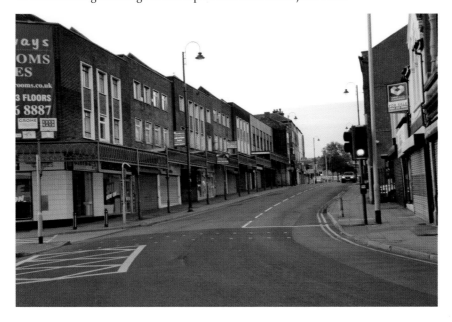

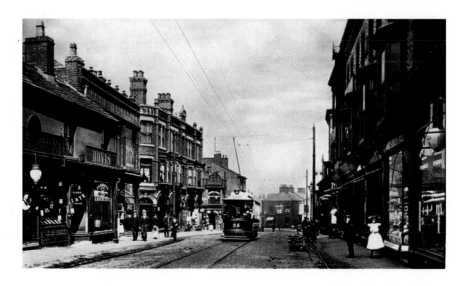

Lower Market Street, c. 1905

Above: Beard's tailor's and clothier's shop is prominent on the left. Next to Beard's is a bakery advertising Hovis, and Fry's and Cadbury's chocolate. The sign above the next shop displays the legend 'Mart of Exchange'. There is a bank on the corner of Milk Street and what looks to be an ironmonger's, perhaps Brooke's, on the corner of Cross Street. Compare the view with the one below, taken in 2012, and look in particular at the Taste of India and Pound Shop on the left with the arched lower windows. It is the same building that the tram is passing in the above picture, but half of it has been replaced by the white Barclay's Bank building near the traffic sign. Brooke's ironmonger's building has been replaced by the new Brooke's Surgery, and the remainder of the buildings down to the corner survive, although somewhat altered in appearance. All of the shops on the right were replaced in the sixties from where the tram is down to the corner.

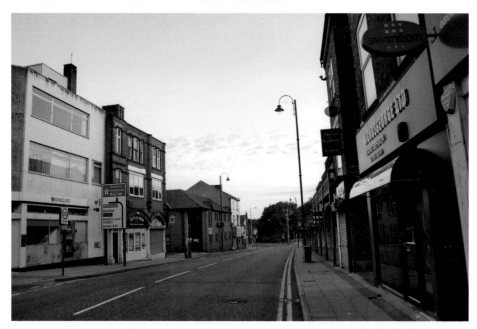

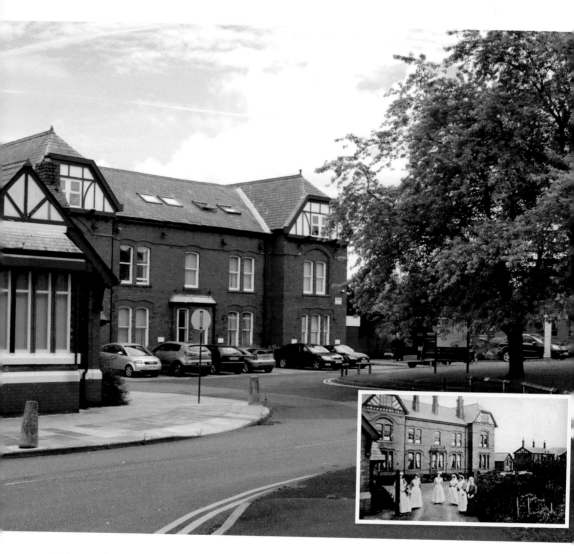

Hyde Hospital

Inset: A matron and some nurses pose outside the Hyde Hospital, on Grange Road South, around 1912. The 'new' hospital was opened in June 1905 and its address then was Backbower Lane. It replaced the 'old' hospital, which was on Mottram Old Road and had opened in 1886. *Above*: The same view from July 2012. The hospital was converted to offices for a residential home.

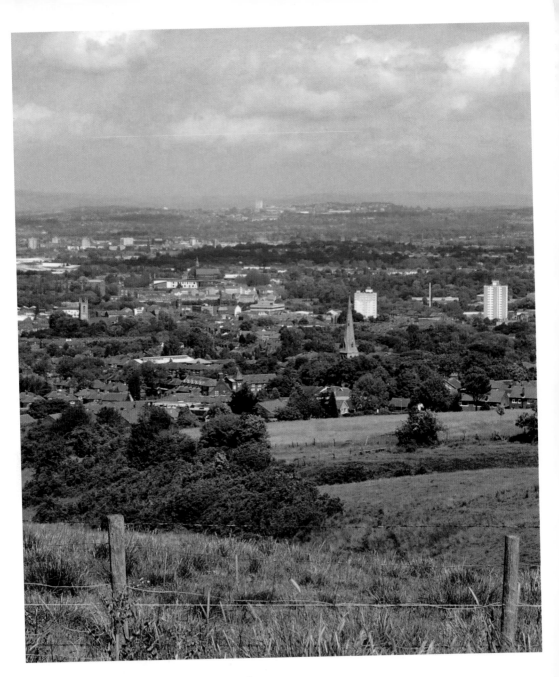

View of Hyde and Gee Cross from Werneth Low
This view was captured in 2012, with the spire of Hyde chapel, Stockport Road, Gee Cross, prominent in the foreground. St George's church, John Grundy House and Chartist House are also easily identified and Hyde Town Hall can just be seen. The roof of the Social Security Offices on Clarendon Street is dead centre and St Paul's church in Newton is just above to the left. The orange block in the distance, as if you didn't need telling, is the Ikea store in Ashton-under-Lyne! Oldham and Rochdale are in the far distance and the Pennines form the backdrop behind Milnrow.